Silhouettes 3

Michael O'Connor

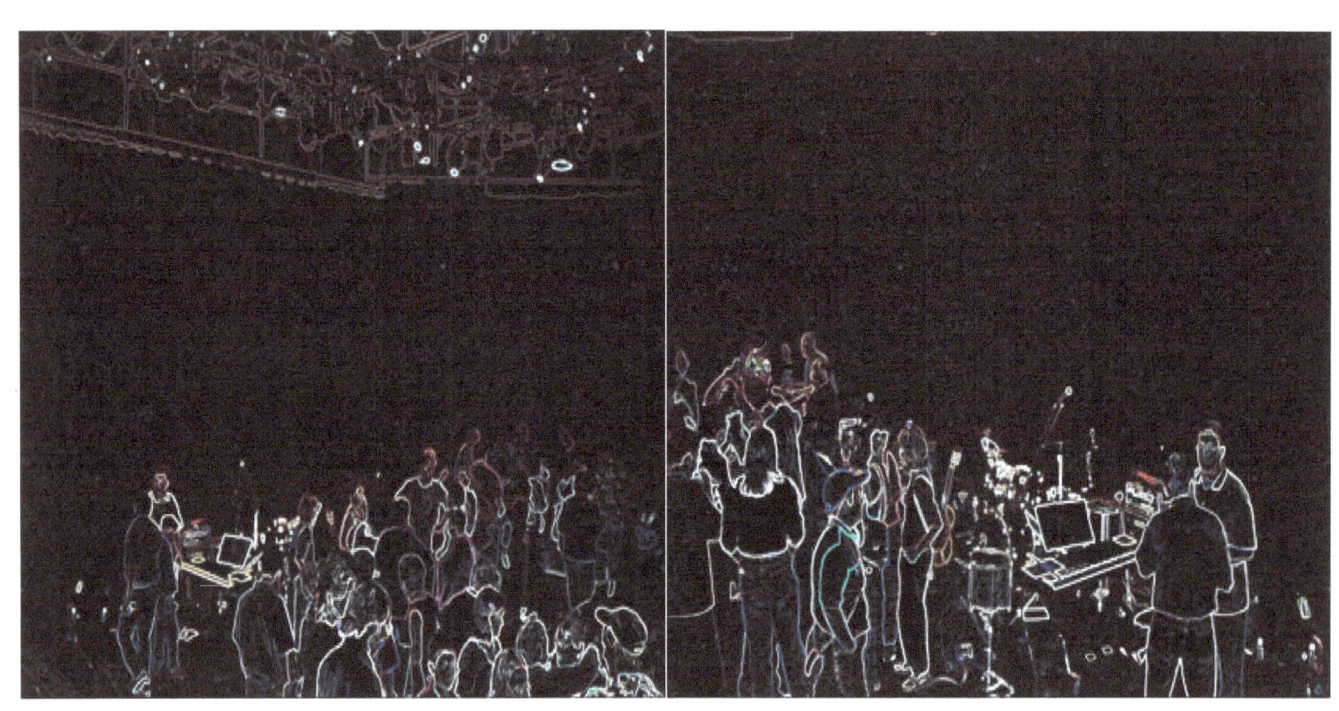

Jam Session, 2003, Photo panarama

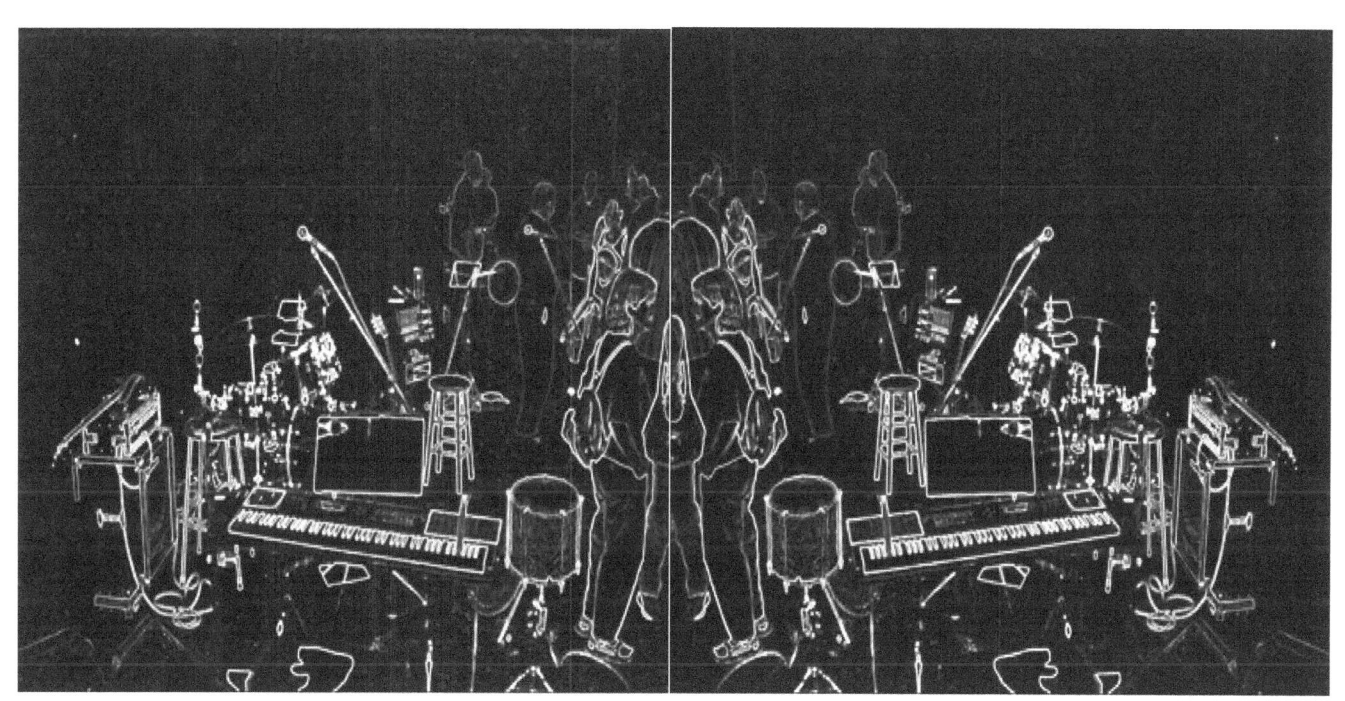

Converging, 2003, Photo panarama

COPYRIGHT © 2004 MICHAEL O'CONNOR

COPYRIGHT © 2003 DORYINC

ALL RIGHTS RESERVED.

No images or text from this volume may be reproduced without the express written permission from the author.

Artwork photography printed in Menlo Park, California

Front cover image: *End of the Game*, 2003
Back cover image: *Elephant Walk*, 2002

For my soul mate Kitty

Contents

Preface	9
Introduction	10
My Letter Home	12
Truth is a Dreamscape	14
Running	16
La Fe Estafette	17
Super Nova Bosa Nova	18
Is the Planet Earth a Political Question	19
Falling	20
Tacite Island Affair	21
Muddled Heap in the Shadows	22
Save the Last Cance for Me	23
Evolution Tribute to Rodin	24
Tribute to Rodin	25
Embracing Still Waters	26
Three Vessels	27
Baja Beach	28
A Very Tall Still Life	29
Baja Bay Secrets	30
Dancer's Web	31

Balloning at Dusk	32
Space Cavern	33
Dante's Trail	34
Glass Spaces	35
The Elephant Walk	36
End of the Game	37
Jungle Mist	38
Journeys End	39
Let the Walls Come Down	40
Maverick's	41
Suspects	42
Rain (Under the Umbrella)	43
Tightrope	44
Trapped	45
Woven Moments	46
Zodiacal Light	47
Abandonment	48
Cultural Clash	49
Face It & Broken	50
Neon Blue	51
Screaming	52
Sitting Blue	53
Sitting Blue (Poem)	54
Single Moments & Reflect	56
Kitty	57

Michael O'Connor is a SF Bay Area resident. Michael splits his time working with technology startups in the SF Bay Area, and working as a fine arts painter, photographer, sculptor and writer.

Preface

The artworks and poetry contained in this volume are a culmination of the works that I have completed over the last decade. One particular aim of putting this collection together was to gain a perspective of the works in a historical context, not unlike the method one would use to research the history of one's family tree. I put this in a historical context because most of the works contained in this volume were generated against some significant event that had a profound impact on my life.

Like many family trees there are some missing and broken branches. Because of my love of the trade and barter system, many other works (including works from a previous decade) are in the hands of friends and associates; across several continents and many countries; that I have not been in contact with for quite some time. And I have no regrets in that regard—so I am not the first person to loose track of some very personal articles, but feel nonetheless comfortable in that they are being enjoyed by my extended family.

The title that I used for this volume, *Silhouettes 3*, represents a notion that I have carried with me during the last two decades. It is the notion of a standard for measuring human communications that can be represented as signals, symbols and noise. The other half of my life has been deeply immersed in the advancements of communication technology. So I am very certain that many other disciplines use signals, symbols and noise in an almost identical context. As a result I have become quite comfortable with the convergence of science and technology with artistic representation in the same span of time.

Michael O'Connor

Introduction

The approach to societal phenomena here proposed provides a place for all societal data whatsoever including those conventionally designated as ethical, idealistic, spiritual, or esthetic.— George Lundenberg

It is only by collective perceptions and sensations that I am able to fathom the initiation, evolution, and the ultimate conclusion of the environment in which I exist. For me personally, this environment exists like the framework that surrounds a painting; the contents of which lies within; only representing so much information like some silhouette—as the greatest of ideas represented by the artist at that precise time and place.

Within this framework there also exists a sort of birth, lifeline and timely death—so it may be a simple notion—that is a consequence of the thoughts and aspirations of the artist reflecting the feelings, values, beliefs and attitudes of the society of which he gives love to. I am simply reaching for an answer through my art. And while reaching for that answer I grab hold of many concepts and ideas, and master them analytically so that I can begin to formulate and postulate the very nature of my existence within this environment of which my greater universe frames.

I turn toward this universe and begin to transplant preconceived ideas on to the canvas or board, making sense of my thoughts, and apply the medium of colors that will best represent the concerns I have over my society. I do this to introduce myself to society. And so now that I have introduced myself I feel that I have a stronger heartbeat, and I am in a better place to master my visions within the paintings, so that the masses that live outside of my vision will be able to appreciate yet another opinion of this society.

The painting begins with a heartbeat, and grows stronger with every stroke of my palette knife. The strokes become quite loud with opinion, and louder with each passing of the knife against medium against surface. And an image appears; synthetic with complexion; spinning and orbiting light passages in my eyes.

My latest vision has started—and so the geodetic shape of the earth begins to unfold and many hidden mysteries are becoming clearer. And it suddenly dawns on me that I have painted millions of atoms on to the surface; spherical masses of globular medium spread under the rounded edge of the knife; and it becomes apparent to me that this new evolution will not be able to contain the mass of my feelings, values, beliefs and attitudes infinitum. So I apply additional layers to this section of canvas or board.

I attempt to keep track of the layers—so it seems as though I am a statistician—and a philosopher in my own right—who has counted two hundred and fifty two million vectors in my knife strokes. That is one stroke (more or less) for every person that exists in my society, in the year 2004, and I will have to continue to add an additional two million strokes every year thereafter.

By itself the figure means little to the other societies who have begun to gather around my own, to find out just what it is I am painting. Because I am social, I can not be indifferent to the growing crowd. I will need to figure them in somehow; into this composition; all of the necessities needed to sustain their lives within the framework of my art—in this vision I postulate, ascertain and continue.

I also have an expectation that the growing crowd may not be entirely appreciative of my coolness and I do comprehend their need to interact with and perhaps influence my world. I never wonder, on the other hand, if this crowd will become so despondent and move away. Something else about this crowd has affected the remaining strokes that will be needed to bring this canvas or board to completion. So I duly note that the crowd speaks out volumes of the fact that a large percentage of the vectored knife strokes will need to live a broader and longer span. And this will undoubtedly influence the progression of my work.

I stand there not at all dumbfounded. Though I am just beginning to understand how this will affect my next knife stroke, and to this work that now has a life expectancy of its own.

But I am not stunned for long in regard to the compulsory signs that societies have thrown me. And I bow to the incisive wisdom of the societies that I have visited and lived within. This is what I have come to expect out of life. And this is what I get as a reward for inclusion.

Instrumental to any society is the notion of continued evolution, and the re-adaptation of life to the environment. I feel that we are a paired couple: waiting, anticipating, absorbing and maintaining a sense of perspective.

And now I am aged—so it figures—and I have embraced this family of ideas that make my work sound. This is the heart of the matter—a discernable unit of measure—an interactive structure for analysis.

The heart of the matter is that I must see the nature of my work as the anthropologist and sociologist sees the nature of any unit of people struggling for survival. Thus, my art has become the maintenance of my life.

MyLetterHome

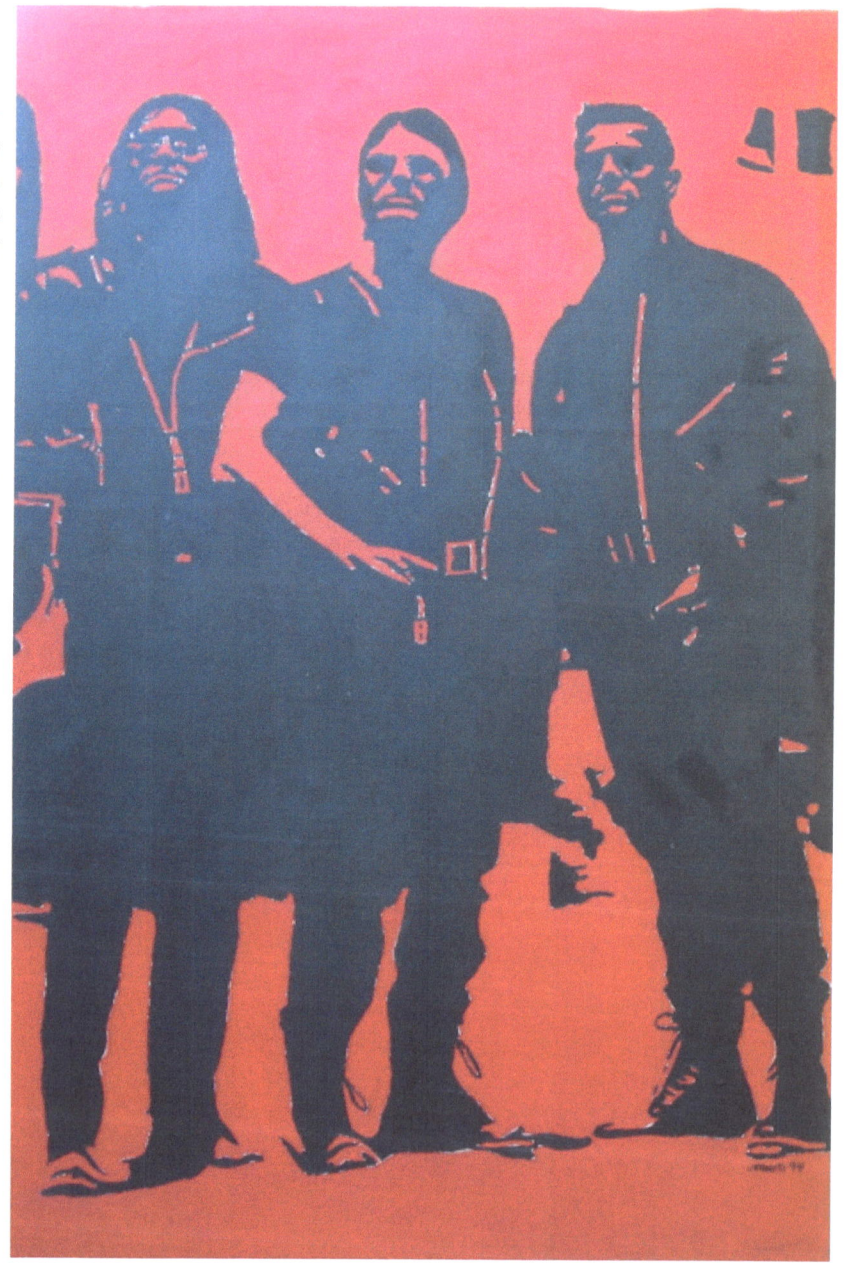

In All Our Glory, 1994
Oil and acrylic on canvas
80 x 46 in.

To whom it may concern,

Today I woke up to the sound of my own imagination, so I climbed outside of my own mind and took a closer look at this mirrored image. And as I peered out more closely I found the following screen play already in progress:

Fade In:	*A famous and violent mob scene.*
Fade Out:	*To black on red.*
Fade In:	*A recognizable trio of terrorists.*
Fade Out:	*To red on black.*
Fade In:	*Rapture noise following a face imitating my own.*
Fade Out:	*To black on red.*
Fade In:	*A voice screaming "Where I was a few hours ago is diminished."*
Fade Out:	*To red on black.*

And it was perhaps in that memorial hour that I should happen to think of the rain; cold and foggy winds are creeping up the shoreline over the long since abandoned pier; and to where three might have stood so symbolically. And the sun shines and pokes its way through the fog bank making a deposit on to the red stained sand, and it ruins the whole feeling and sensation of B & W.

"Poke through it all, if you will," I threatened just as loudly: so lustful, standing before this growing city of lights, before all of its subjects, not at all in awe, and casting out my unwanted arms; still chiefly unwelcome though patriotic; on to this City by the Bay. Thus the rain suddenly comes in voices of the dead, and the wind quickly follows and provides comfort to all; those who patronize it known by no other name; with no genuine displeasure as the vision continues in vain.

By the next sunrise the skies are still in anger and refusing to change until the afternoon; metamorphic moons to all other observers; still hiding beyond those fancy dark glasses, and telling no one until they have all reacted.

"How ugly is the sun on the city by the bay, when full of it, is how ugly I felt when running on empty?"

So give us our daily cold day of glistening bold gray, with no more illusions or visions of lofty green hills, through the splashes of French red wine, always craving for the sun to eventually come down and always braving to remain in this fog that surrounds us. I am certainly not to be the first to be struck by that last resemblance between what are considered obsessive acts in neurotics, and those daily observances, which are by the way just another means of expressing *"the show goes on."*

In time there will be much more to say by those activists and historians. But due to the current lack of organization, so characterized by complete and near total conformity—by some standards—the lack of useful dialog is due to the lack of balanced ion exchange—our collective chemistry has become a rather weak mixture. That is to say, *"These three silhouettes met down town to discuss their relationships: One was killed in action, the second was embedded too late, and the third had his soul purchased."*

And if you think that I have left anything or anyone out, please write back soon.

Sincerely.

Truth is a Dreamscape

Truth is a dreamscape of such authority and such great color palette may have represented, by that signal, symbols and noise the habitation of the visual canvas, in which it presides over humming the cords of silhouettes in inestimable glory.

And I may have commented on this whole dreamscape, saying, "One thing have I desired all of my life, that will I see and filter this visual noise, and that I no linger dwell in the sanctuary of dreams all the days of my life."

If I continue to seek refuge in this dreamscape no matter how pure my heart and soul where I truly dwell well intentioned, burning with a desire to entertain a controlled palette, I pray, "Renew a righteous spirit within me, where it is certain that all desire be the embellishment of the materials which lead to a masterpiece, which is the place of this dreamscape. "

For I myself longed with a most ardent desire to become the founder of the masterpiece frequently spilling the colors of myself as a human, albeit bloodless in this vision, but will not merit it and entrusted almost all the needful resources in red, green, yellow, blue, with hints of black and white.

I had awoken and read in my hastily written notes that the dreamscape had given to me a mandate to build a stereo vision, and had chosen by name the masterpiece of the canvas, and had filled its coarse surface with the spirit of wisdom and understanding and knowledge in all learning for making works in red, green, yellow, blue, black and white, on two-dimensional canvas, and in three-dimensional vision of convection of every kind.

Without porous reflection I had discerned that I delighted in that which I assigned to the power of embellishment of this kind, the execution of which and guidance of the id within me, and I believed that nothing of this kind could be endeavored without narcissistic inspiration.

Therefore, attractive I, when I have adorned this media with such embellishment and with such variety of work, I will no doubt believe without misgiving, that of which I will clearly demonstrate that whatever full color palette that my heart and soul has been filled in infinitum—so I will continue to learn, master and devise by my own grace a tenfold appreciation.

Humble I, servant of the dreamscape, worthy of the name and profession of a pure and absolute artist, wishes to all who are willing to avoid idleness and shiftlessness of the mind and spirit, by the useful occupation of their eyes and imagination and the agreeable contemplation of new masterpieces, be the only true life reward.

Viewer I, take both care and concern to attain a mindful capacity for all of the arts and skills as if by right.

My skill must be sustained for this sole purpose with the passage of time, transmitted as signals, symbols and noise, to the predestined attainment of enlightenment and pious devotion to my art.

When this has been attained, let no one reproach me to humbly render thanks, nor let myself conceal what has been given in the cloak of envy; that dreamscape delivered through that observable palette.

Garden Sculpture, 2003
Recycled steel
48 x 24 x 16 in.

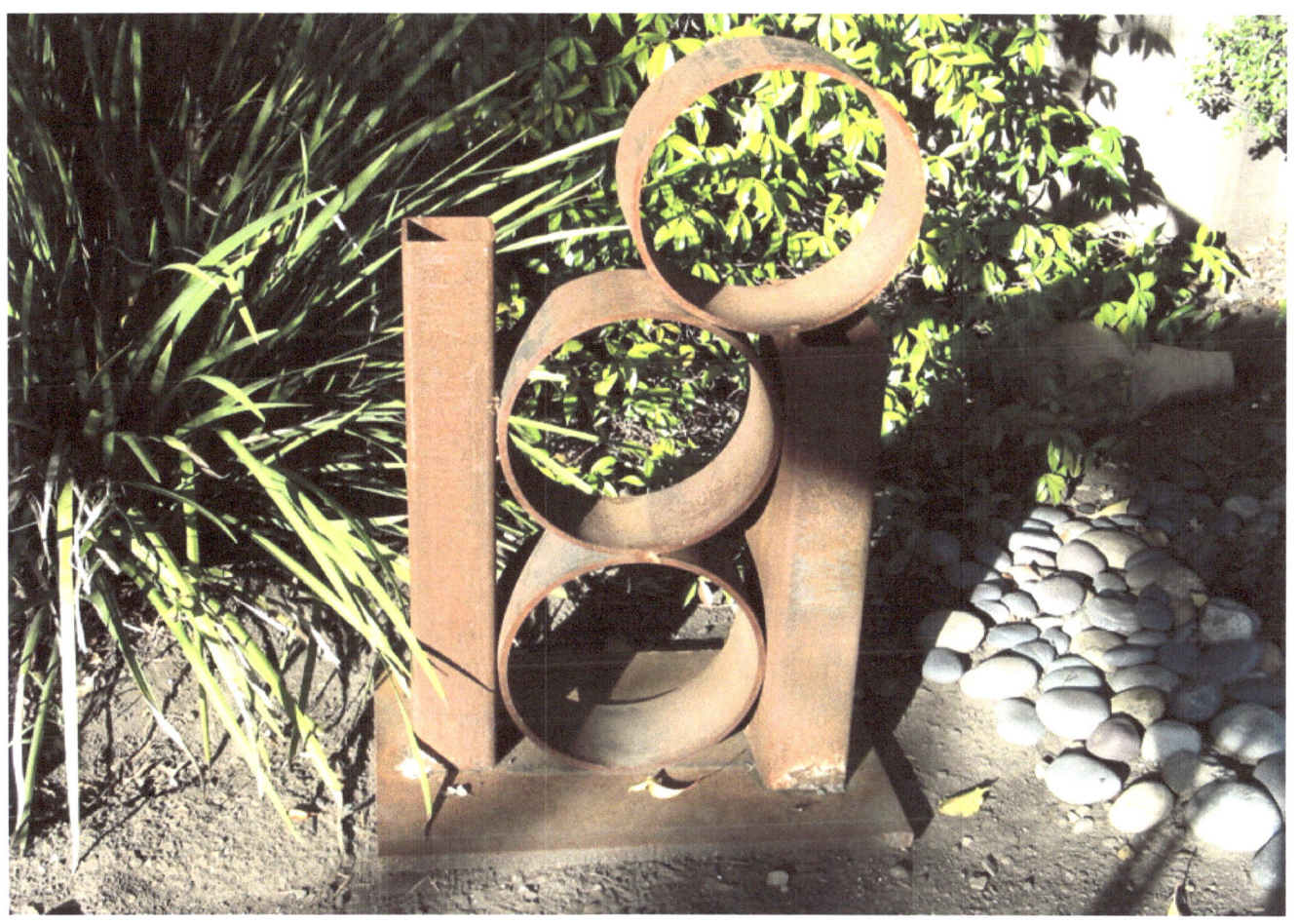

For I, can not repel all vain-glory with a joyous heart and with simplicity dispense to all who seek, in fear of judgment, on that art mercenary who failed restore to his master his talent with added interest; deprived of all regard; merited the censure from art's own critics.

Running

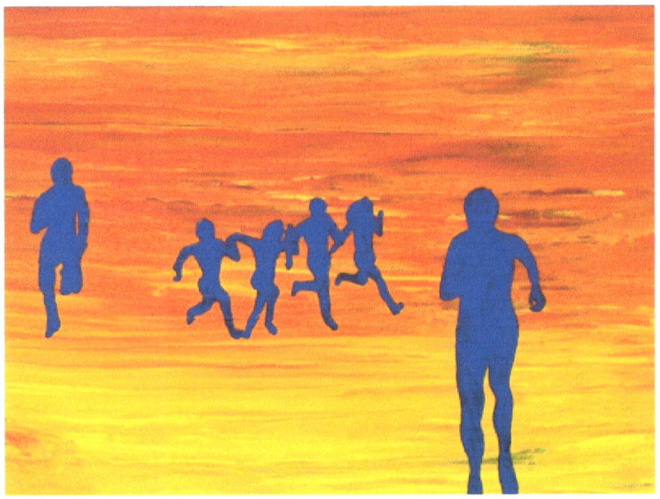

Running, 2003
Acrylic & calc on canvas,
36 x 27 in.

Running—so
I was running away from the dark
That hovered over the city
And I considered myself fortunate
That it was a real brick,
Facing the north
That I dodged
And was allowed to escape
Through an alleyway,
Between the darkness,
Before history,
Beyond the columns
Toward something I saw that I wanted.
But
After laughter exploded,
Following a sequence of jokes
Through a valley of taxis
Along an
Avenue I learned to ignore;
In my youth
Even during dreams;
They turned me inside out
As a few passed by
Not to be caught looking
And neither did I.
Night finally comes
Burning holes in their pockets,
As I trickled past
On the basement floor.
All right,
I did see the wall,
Late last night,
Apparently just before
The moon became fuller
As it passed
Over the seventh floor
Of the Mark Hopkins,
Allowing no one
To see.

So
I had already left
Wearing one black shoe,
Still missing the times
I spent with…
"God bless you madam."
And I had always noticed
A hot cup of coffee
With five cents shorter
That the tourists,
While eating
Countertop hotdogs,
Apple pie,
And chocolate covered manners,
Give no one dirtier looks,
As the waitresses
Give change
In the middle of
That avenue.
I meet them all;
The police,
Store
Fire and cook men
And women;
Sincere people with granite faces;
Who watch
Over you and
Over us
With snorkels.
But
Go back inside
Asking questions
"How warm are their hearts?"
The first day,
The first move,
Over that wall,
Beyond that brick,
After
The laughter,
The basement,
And while running

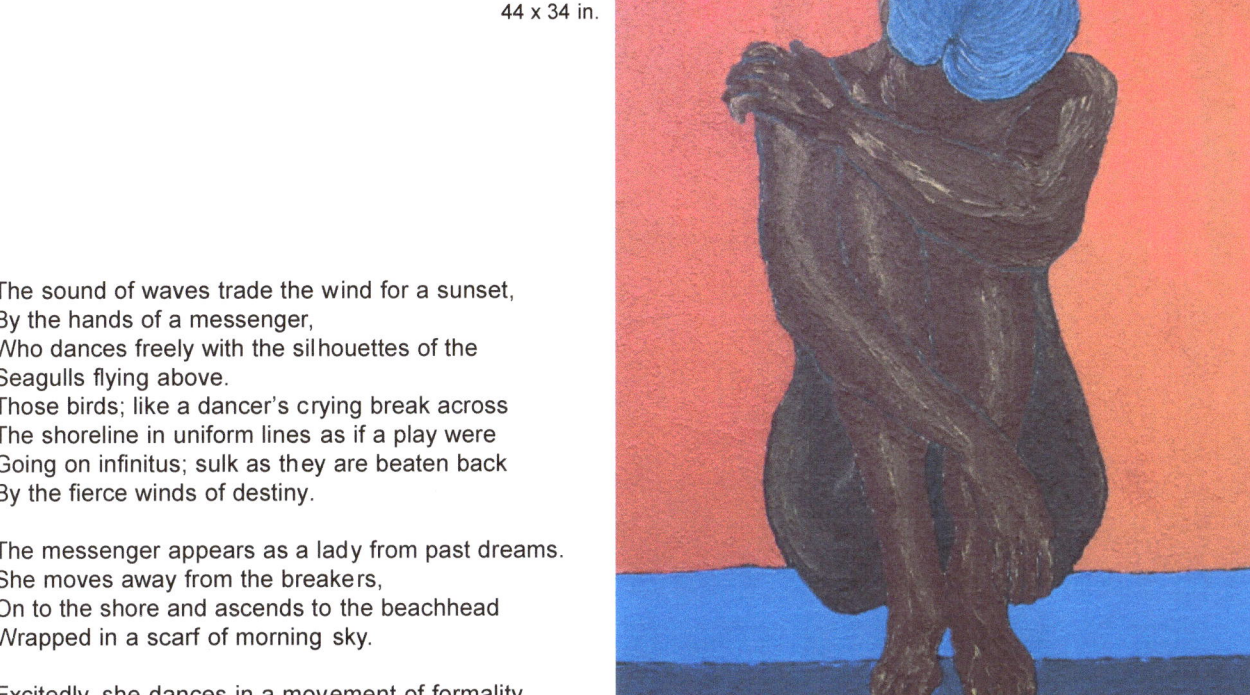

La Fee Estafette, 2002
Acrylic & calcium
carbonate on canvas
44 x 34 in.

The sound of waves trade the wind for a sunset,
By the hands of a messenger,
Who dances freely with the silhouettes of the
Seagulls flying above.
Those birds; like a dancer's crying break across
The shoreline in uniform lines as if a play were
Going on infinitus; sulk as they are beaten back
By the fierce winds of destiny.

The messenger appears as a lady from past dreams.
She moves away from the breakers,
On to the shore and ascends to the beachhead
Wrapped in a scarf of morning sky.

Excitedly, she dances in a movement of formality,
In an attempt to express a message of eroticism
To her observer,
A poet, who belied to
Be the son of Aphrodite.

Metamorphically the scarf becomes flesh; soft
And musk-like; and penetrates the afternoon air.
The earth in return releases its deep earthly
Fragrances and touches the heart of the messenger.

It burns,
Then rapes the afternoon of its warming rays,
Returning a slight reminiscence of light through
The rising moon.

All this and more is envisioned in the mind of
The observer, who
No longer wishes to play the part of Eros and
Closes his eyes to the female figure burning
Before him.

She tries to dance again
But her message finds no channel of
reception.
Sadly depressed,
The messenger turns toward the graciously
awaiting
Sea and disappears into its folding arms.

The sound f waves breaking
On to the shoreline goes on.
Seagulls continue to soar above;
Fading,
Crying,
Waves break again,
Forever and ever
Over the scarf of which only one man will
know
Of its message.

La Fee Estafette

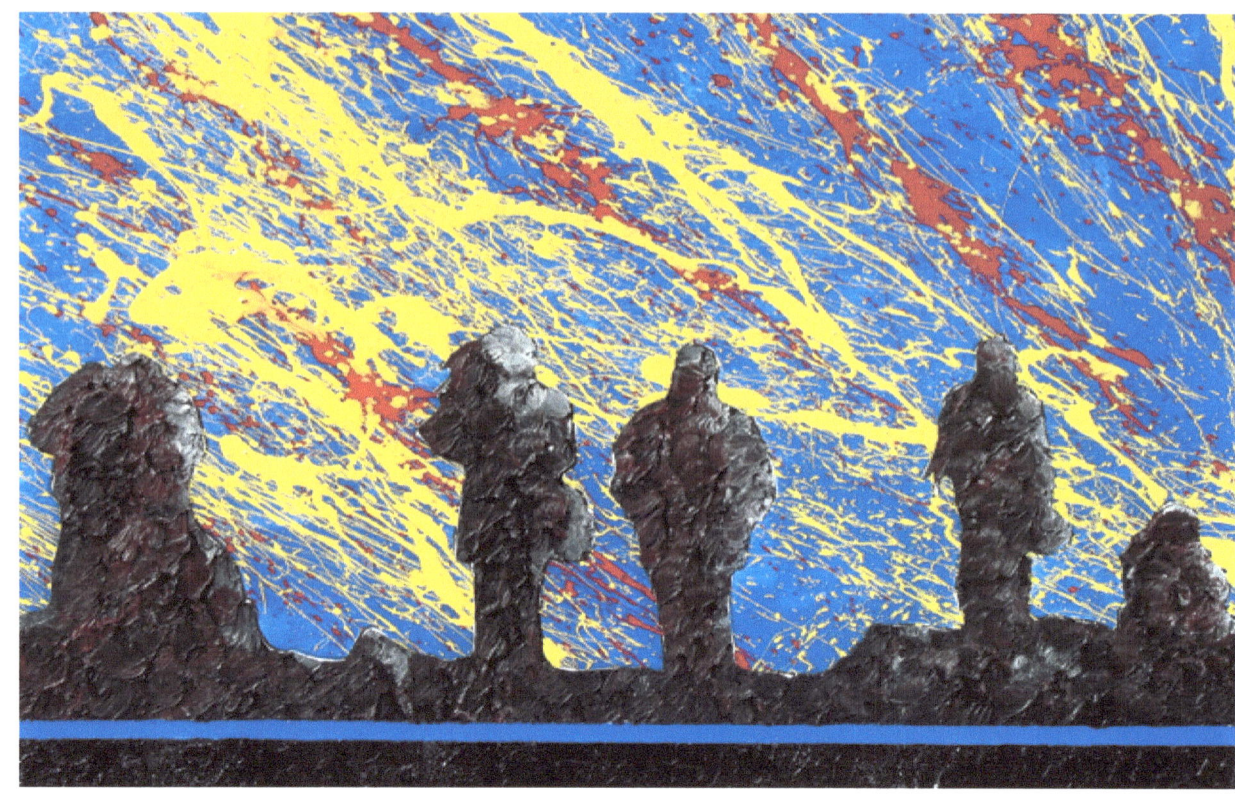

Super Novas, 2002,
Oil & enamel on canvas,
54 x 38 in.

Super Nova Bossa Nova

Late last night while deep to the evening skies
There was a super nova swung into bosa nova
Though not much future in it,
Although I am not an authority;
Just a well read guy.

And my other foot began to tingle,
My hands began to jingle,
While the rest of me went to sleep.

If ever an audience looked,
Ever looked,
For a more inexpensive,
All-in-one-place,
Step-by-step guide to boredom,
Then their universal search is finally over.
While the opportunity
For substantiated wealth
And profits is an undeniable attraction
Of popular stellar physicists,
Or perhaps those TV ministries,

There must be other attractions
That the rest of us can enjoy.

Like travel to exotic places,
And distant foreign lands,
Extended to outer spaces is the ultimate doomsday plan;
When the excitement is overwhelming to all
But the good-willed ambassadors that take us down this hall.
All of this is promised and all of this can be yours.

To get this show jump started,
So the more can be quickly yours,
To get the best action parted,
Ok, just begin listening out doors
To this all important guide
That will take you to your tomorrow.
Just do not wait too long,
And wait, don't just go away.

Is the Planet Earth a Political Question?

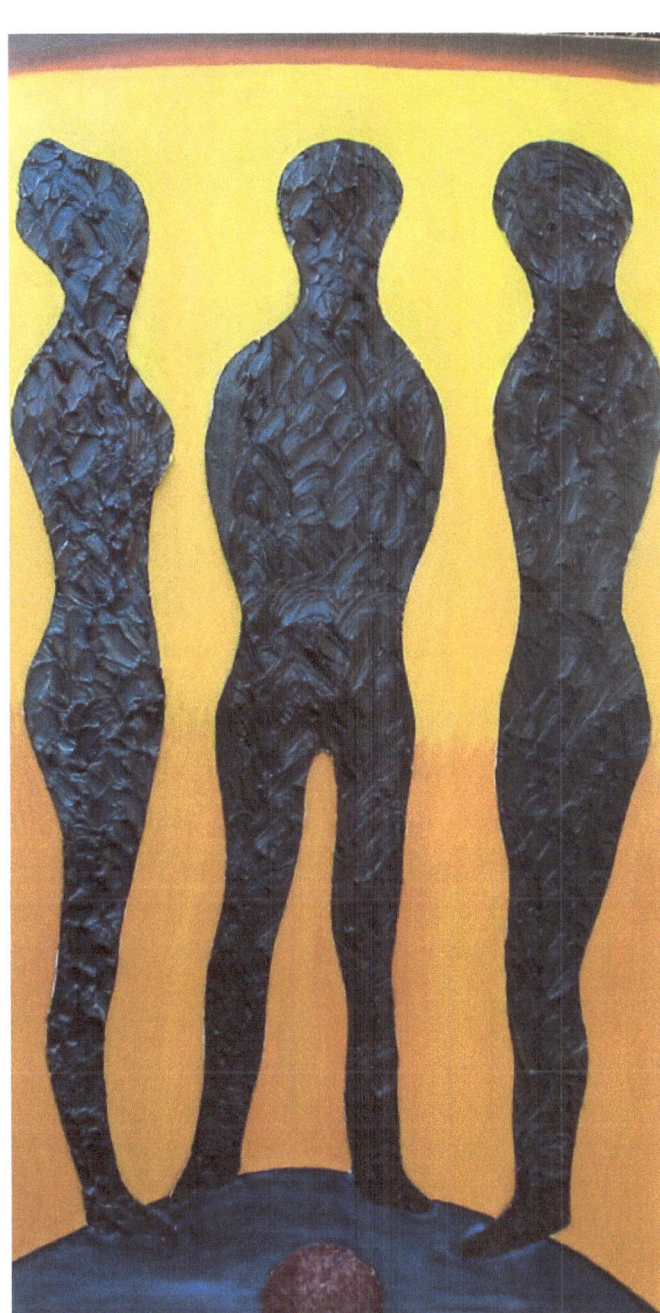

So Wooden and Wasted, 2002,
Oil on canvas, 56 x 40 in.

Politiae legibus non leges politiis adaptandae

The small stood wooden and wasted on the soft planet below,
Starting with the death of a leaf,
By the council of the wind;
Falling and
Blowing
And bouncing;
Across a barren field,
Landing by a single bloom;
And it blossoms to the sound of a jazz base riff;
Throbbing for yet another idea,
Plus a place much more appealing.

And the leaf begins to sing in a beautiful Latin tone,
Recalling great dreams and nightmares,
And orating so softly in once meaningful words and phrases
Yet it feels still uneasy.

Where I see the future lies,
Confident,
In humankind's eyes,
Minimized
At its very best,
At its final resting place-so
Wooden and wasted on the soft planet below.

Falling

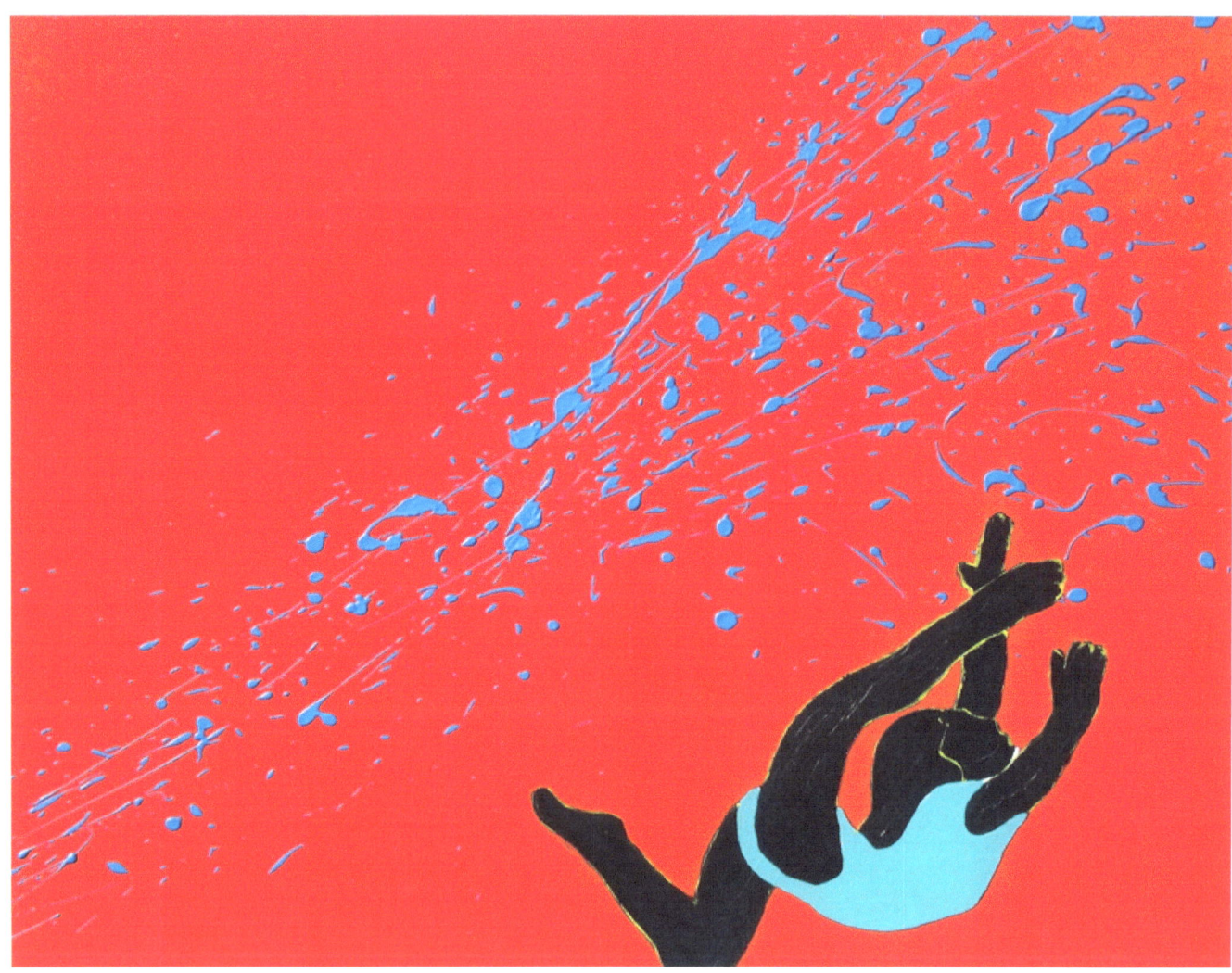

Falling, 2002
Acrylic, enamel & oil,
40 x 34 in.

To come within thelimits,scope,or jurisdiction ofsomething that is just out of reach may not always injure a person, provided that the thing intended can be sufficiently described.

Only one problem remains in the collective minds of civilization:

What was it we were looking for in the first place?

This continues to be an open secret despite fantastically intensive searching. And hence our main and original objective seems to have been lost out in the deepest oceans.

Tacite Island Affair, 1994
Acrylic on canvas
54 x 52 in.

Tacit Island Affair

Muddled Heap in the Shadows

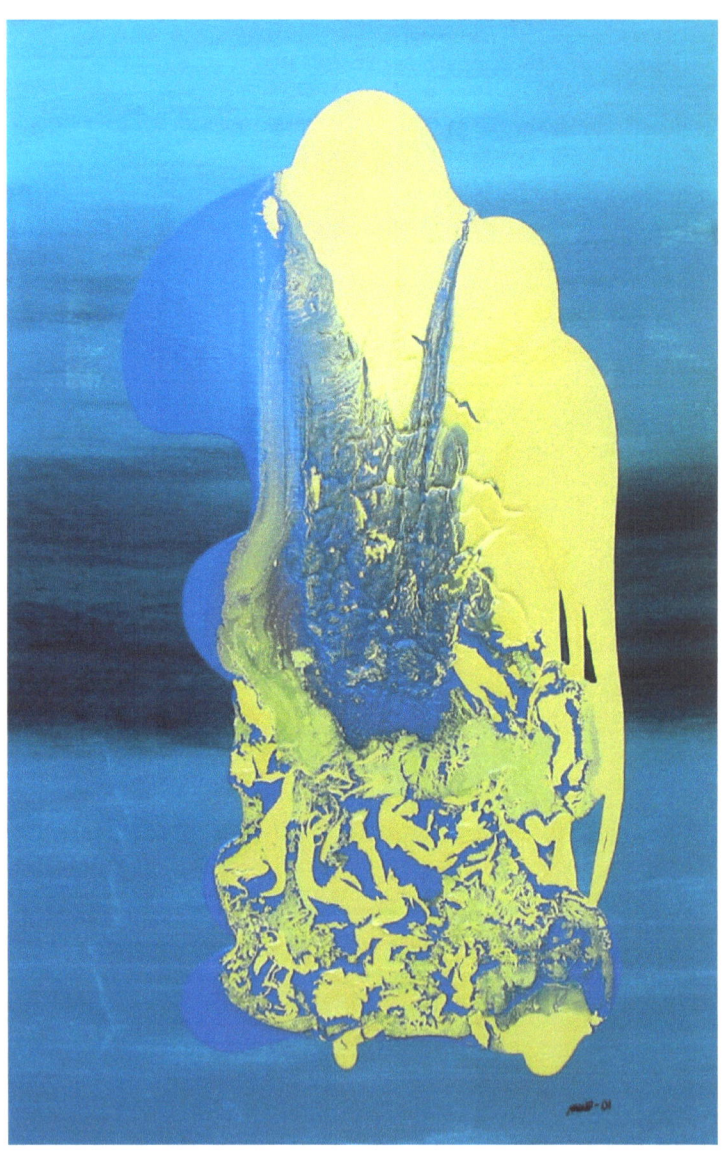

What can I say to what should I say one year after the symposium. The same group was not invited to go forward, or to meet with baskets for breakfast: chili, muffins and wine.

They were all pudgy anyway; persons under delusions of grandeur yesterday. Not the usual yuppies I am afraid to convey; all filled with fear and apprehension; with nothing at all to say.

There is not much to say based in their defense, over such sweet short subjects, and limited time spans, after we talked and talked, and after we last saw each other just a year ago today. It was small talk mostly; bigger orders make me doubtful now; no other physiology, nor closer proximities. Having been through all that before I remember closing the door.

But a few stood distant feet away and thought that I was being kind. But I am through with all of that internship and I am applying what has been left behind. I am also moving toward an extended emphasis, so interfacing is just for Sunday's brunches, with normally low brow people with no soundtracks and no certain hunches--inactivated personalities--and micro minds pulling in no punches.

All else became pure television; abstract and not so self assured; drinking in all excess with an obsessive design to allure. But not at all a religious practice; a definition looking for that need; as I declined to take in to practice, the messages they would leave.

Muddled Heap in the Shadows, 2002
Oil & enamel on canvas
50 x 34 in.

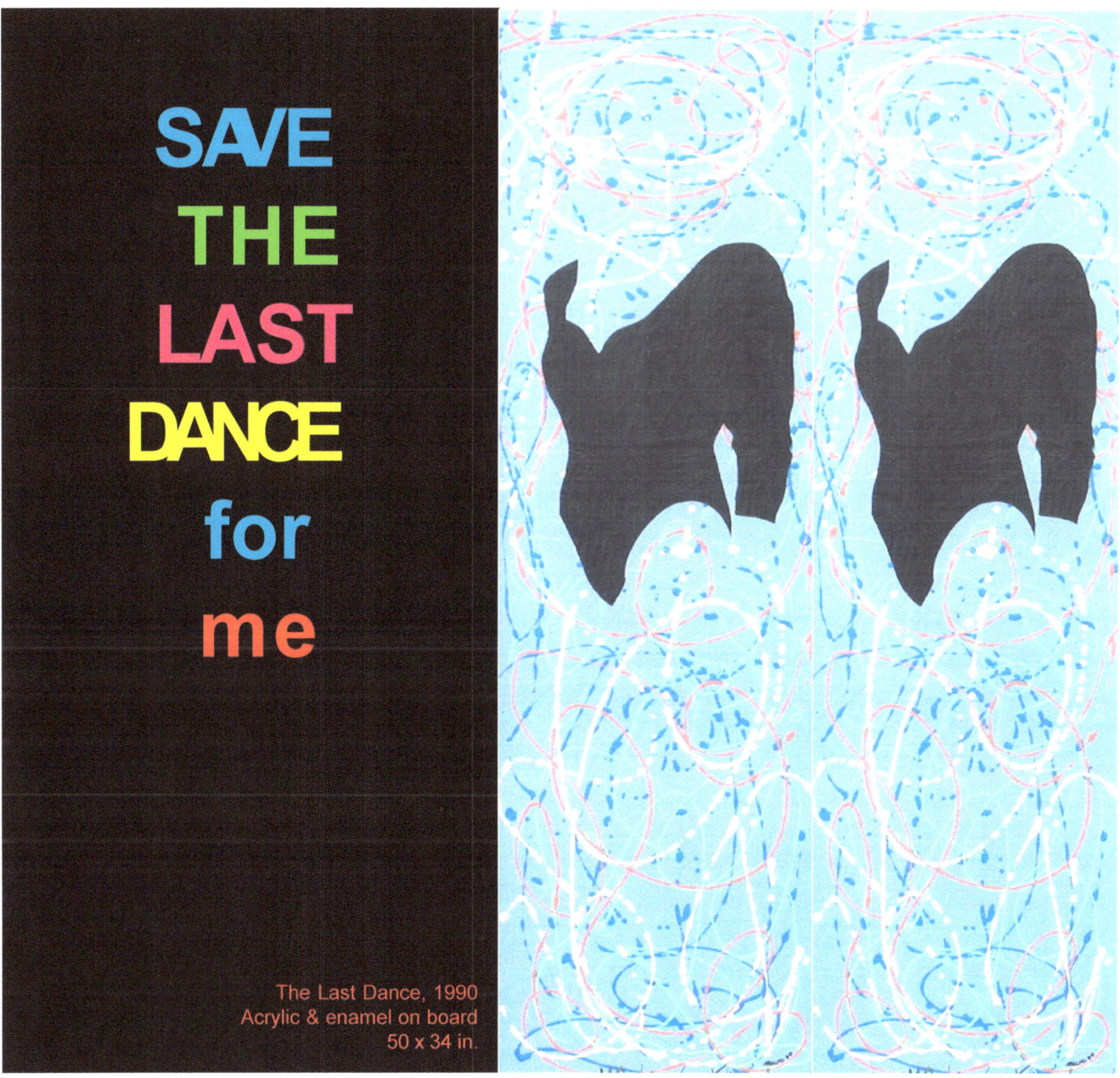

SAVE THE LAST DANCE for me

The Last Dance, 1990
Acrylic & enamel on board
50 x 34 in.

EVOLUTION
TRIBUTE TO RODIN

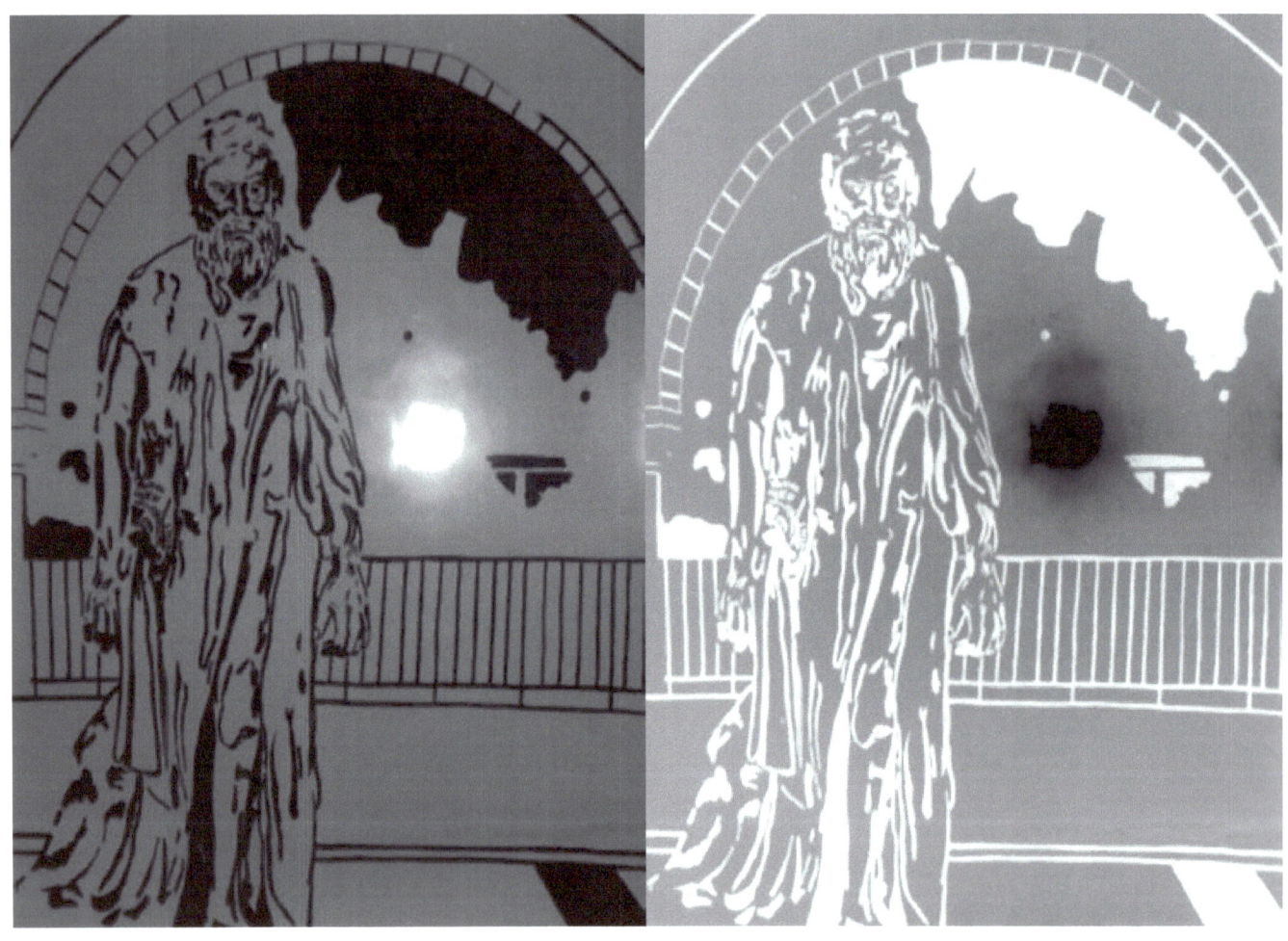

Tribute to Rodin, 1996
Mylar positive
18 x 11 in.

Tribute to Rodin, 1996
Mylar negative
18 x 11 in.

TRIBUTE TO RODIN

Rodin is a fashionable representation of the stirring accounts of sculpture that originated in Europe. The figures that Rodin used represent the romanticism and experimentation of the things that Europeans hold dear; their ancient heritage; in respect to the sobering lessons of displaced contemporary culture and society.

But on the other hand, all of what this represents has been subtly changed, in what we now view as the largest collection of Rodin's works (copies) that resides on Stanford University campus, well beyond the immediate hold of Europe physically. Albeit incomplete, this is my most predominate exposure to Rodin's works. It is less than whole, but still viable, and takes into account the consequences of being exposed to art outside of their respective points of origin.

To study art and history locally teaches us that civilization is the result of a complex sort of mobility of spirit, morality and intelligence, and that preservation for the sake of preservation can be the enemy of civilization.

And for this alone, I am truly happy that I can visit Rodin's works—so literally—fifteen minutes from now.

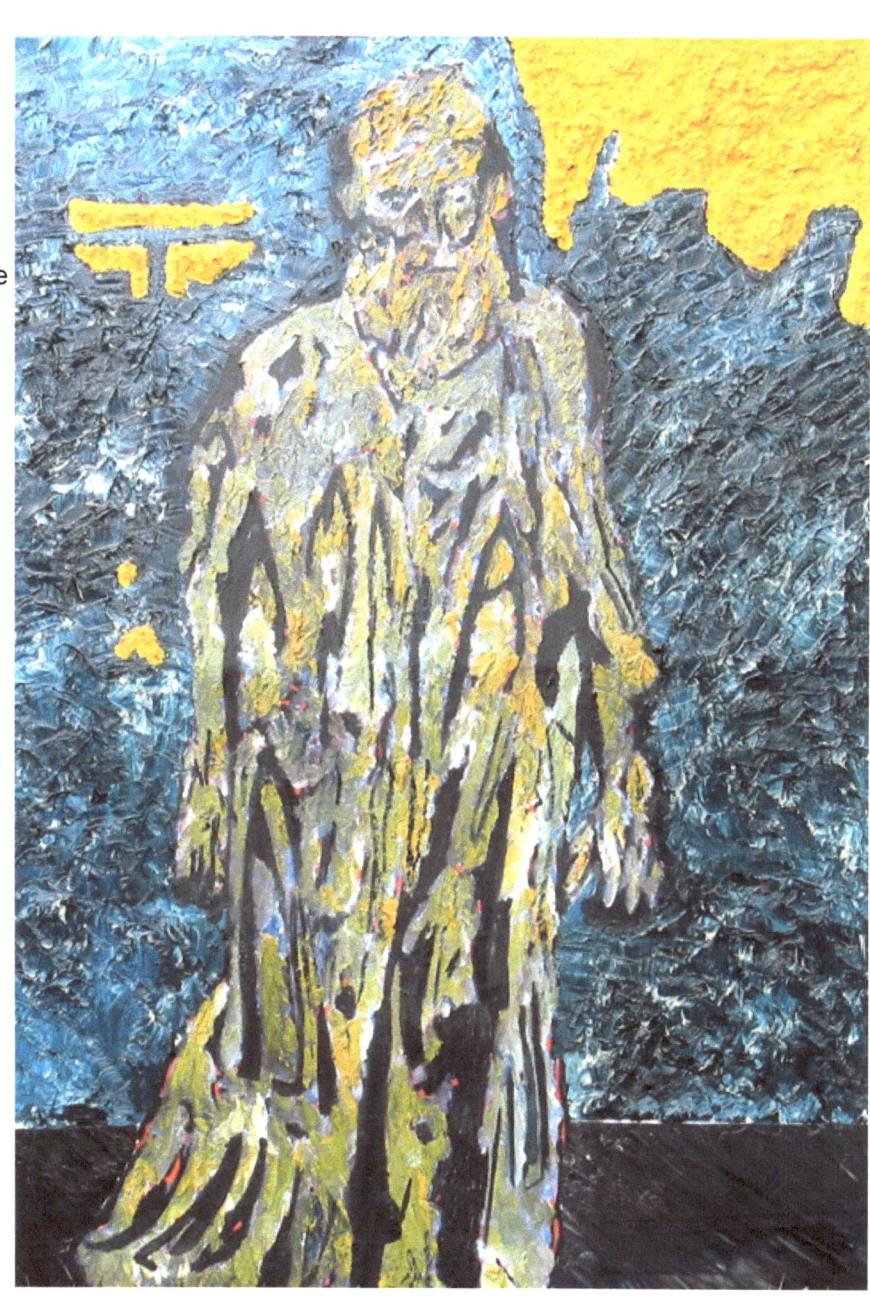

Tribute to Rodin, 2002
Oil on canvas
64 x 51 in.

Embracing Still Waters

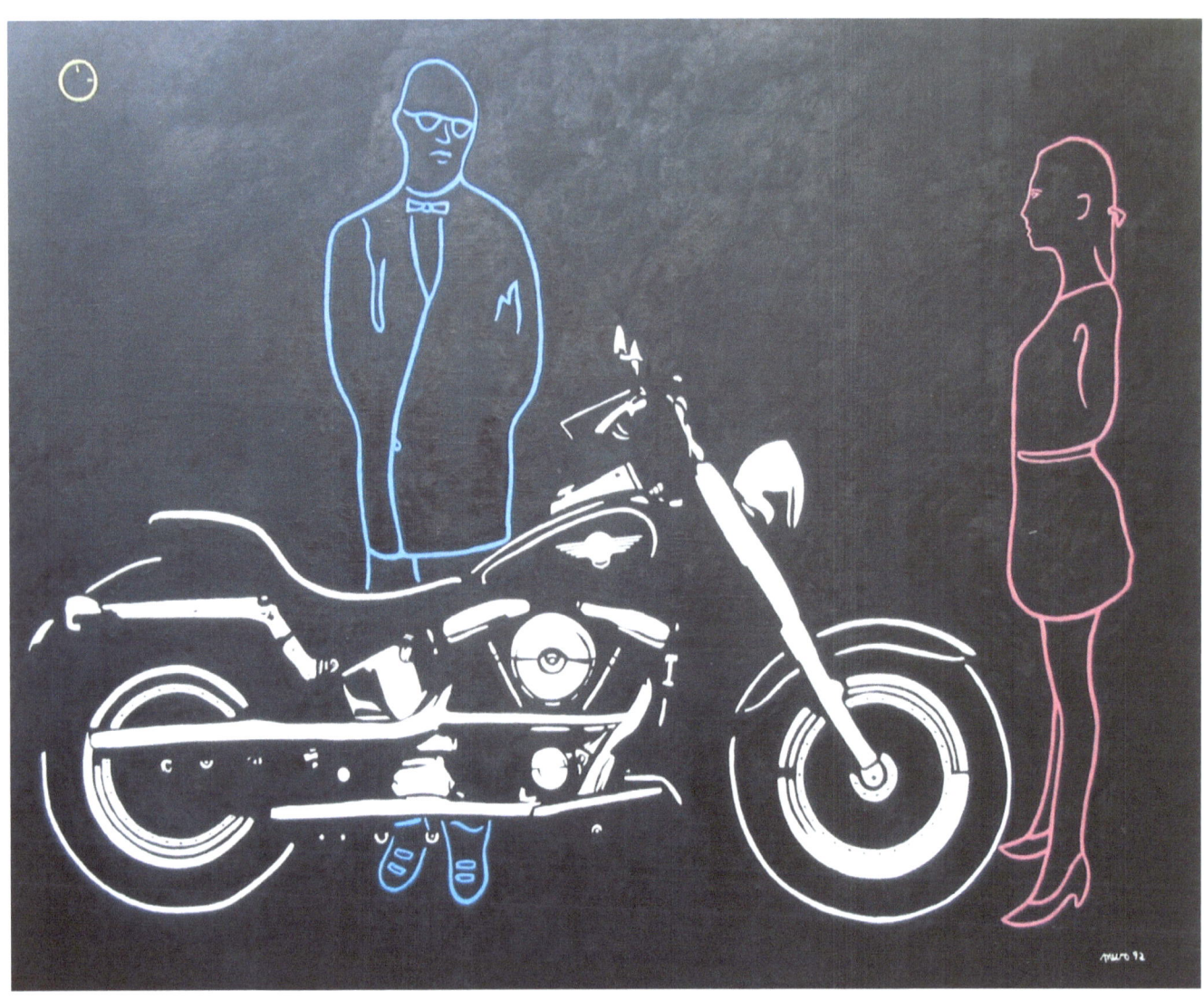

Embracing Still Waters, 1992
Oil on canvas
72 x 63 in.

The Three Vessels

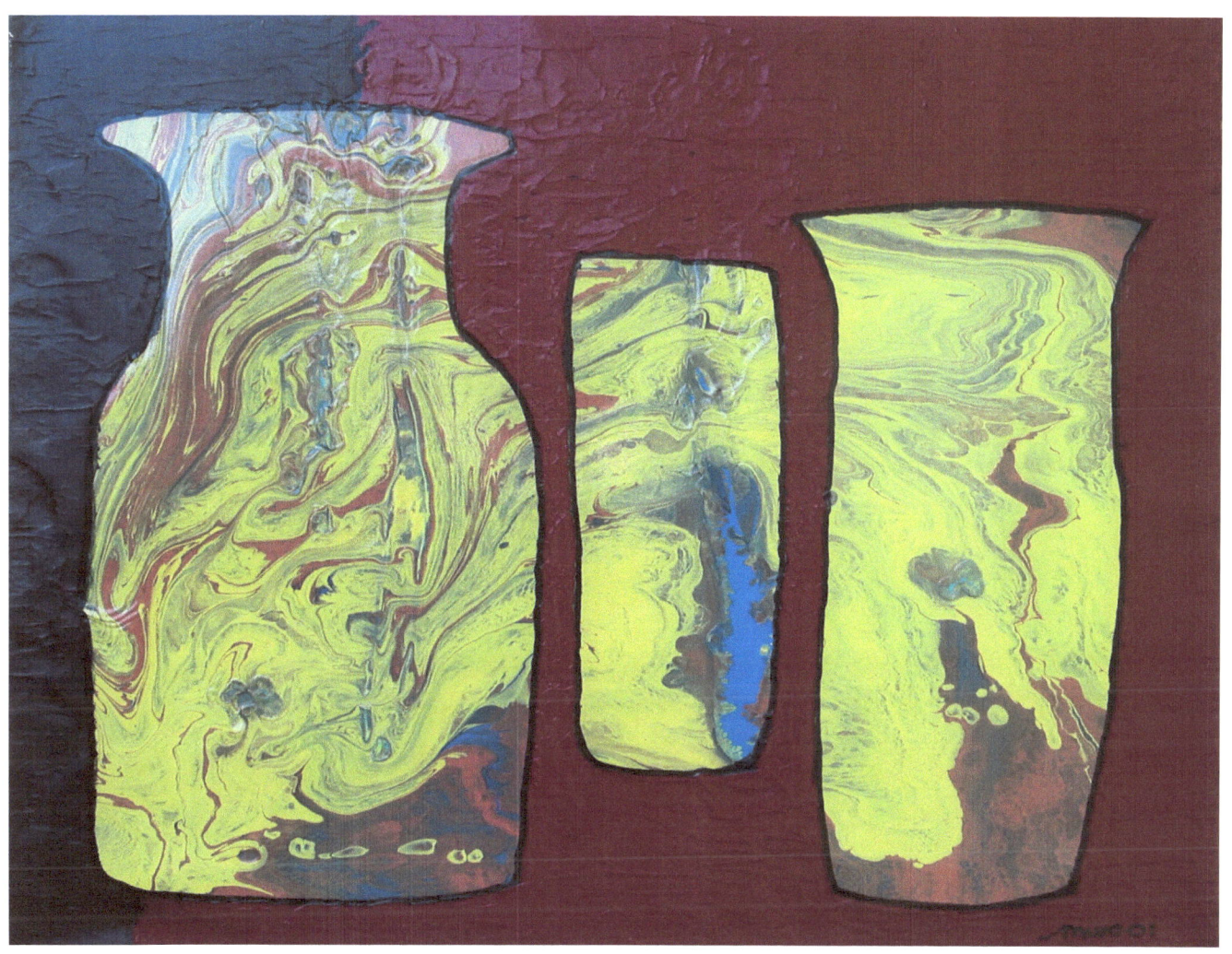

Three Vessels, 2001
Enamel & oil on canvas
54 x 44 in.

Why not do a still life? How often do we get a chance to step back out of improvisation and back into the norm? The answer was found outside of the *Three Vessels* outside of time, space and continuum. Was this a mistake then given that the utmost attention should have been given to the containers actual content; a capacity to hold and withhold matter of uniform consequence; and within the context of the still life's original meaning? Osmotic properties are one of the more important forces that dictate the physiological equipment an object must possess if it is going to survive in a given environment. And of course the *Three Vessels* contain an internal environment that can be survived.

BAJA BEACH

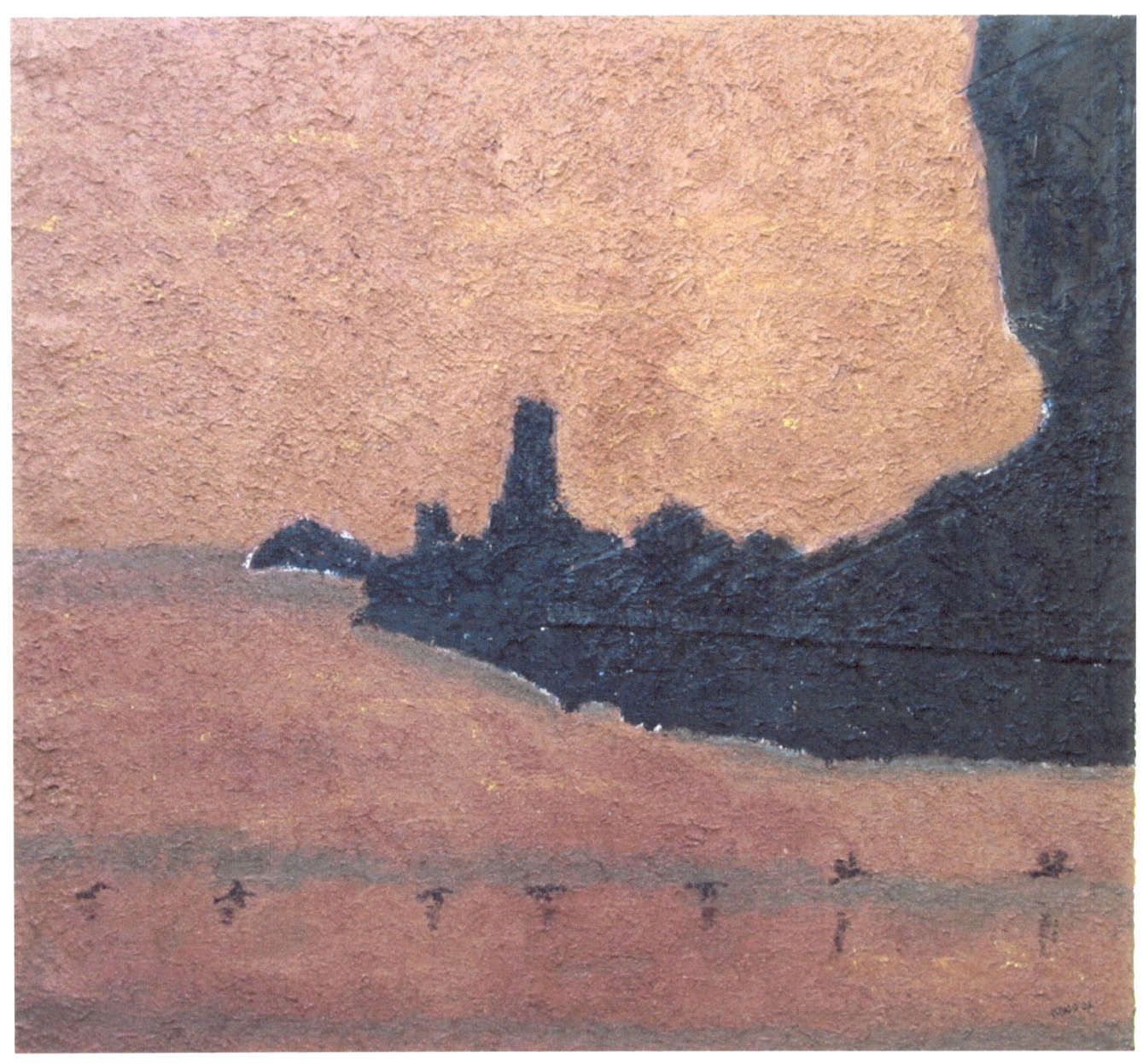

Baja Flight, 2004
Acrylic & calc on canvas
86 x 80 in.

A Very Tall Still Life

There is nothing in information theory that prevents us from considering the configurations, or states, in which a given physical system can be found as messages. And some of these messages are highly probable, and some are less probable.

Recent advances in science and technology seem to suggest that the origin of messages may be related to the availability of informational macro molecules DNA or RNA, and the translation of this information into structural proteins.

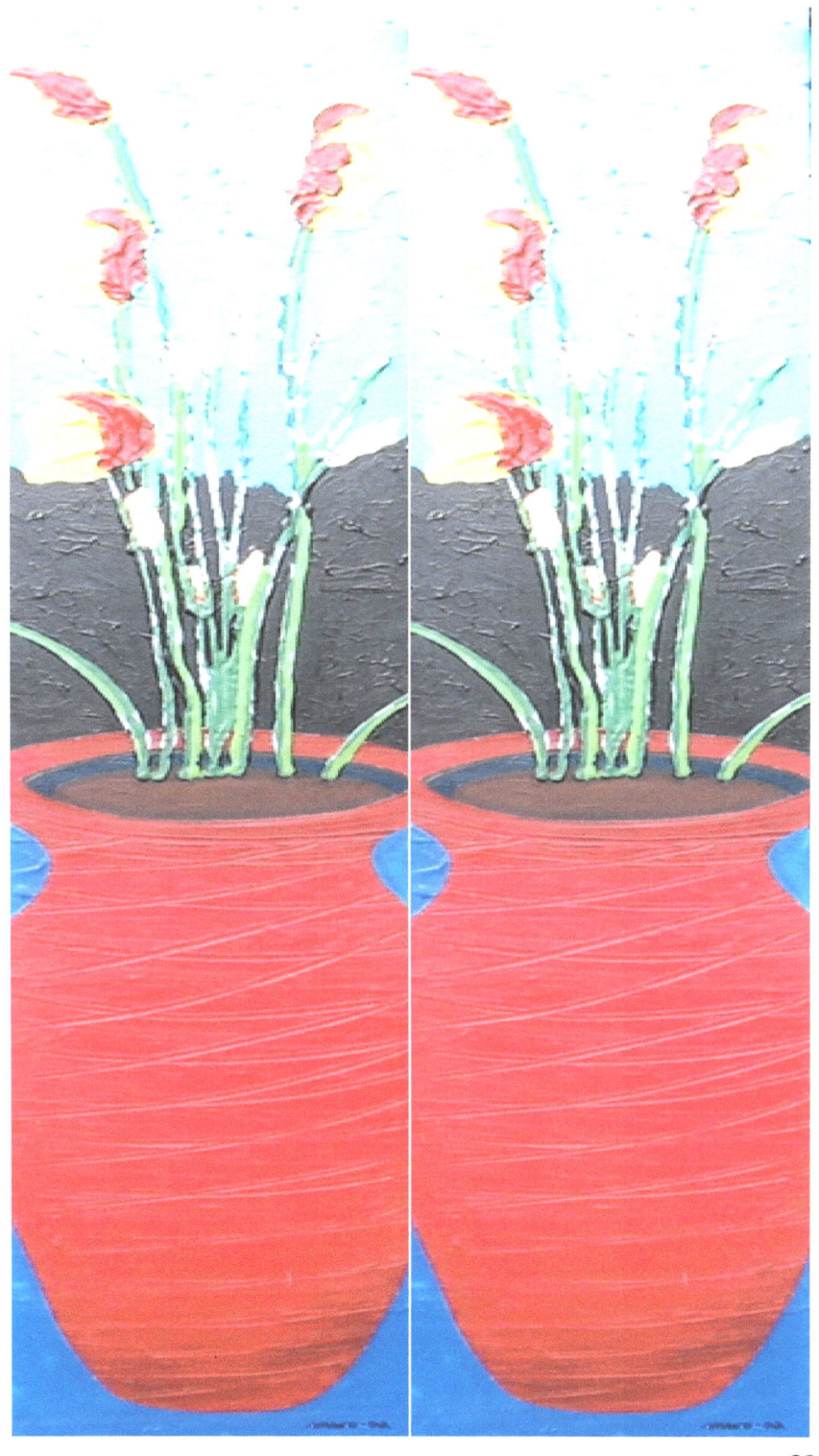

Still Life Tall 2003
Acrylic on canvas
84 x 15 in.

Baja Bay Secrets

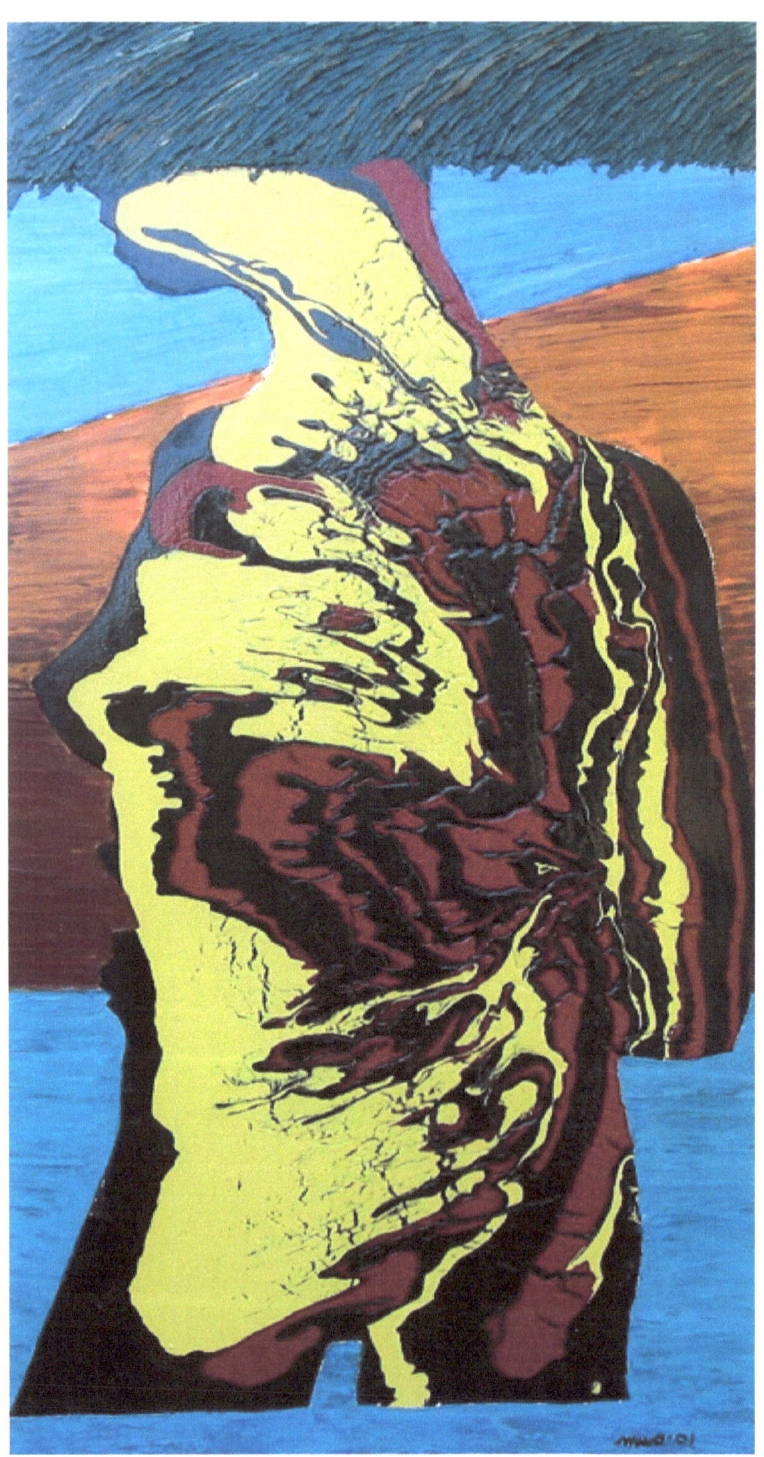

Literally hundreds of reports had been received, virtually all of which the beach patrol knew would prove inaccurate; and so the leader knew the only way to undertake such a massive objective was logically, progressively, and steadily. The sun was coming up, and this method would work again and again.

Beach Umbrella, 2001
Oil and enamel on canvas
72 x 56 in.

Dancer's Web

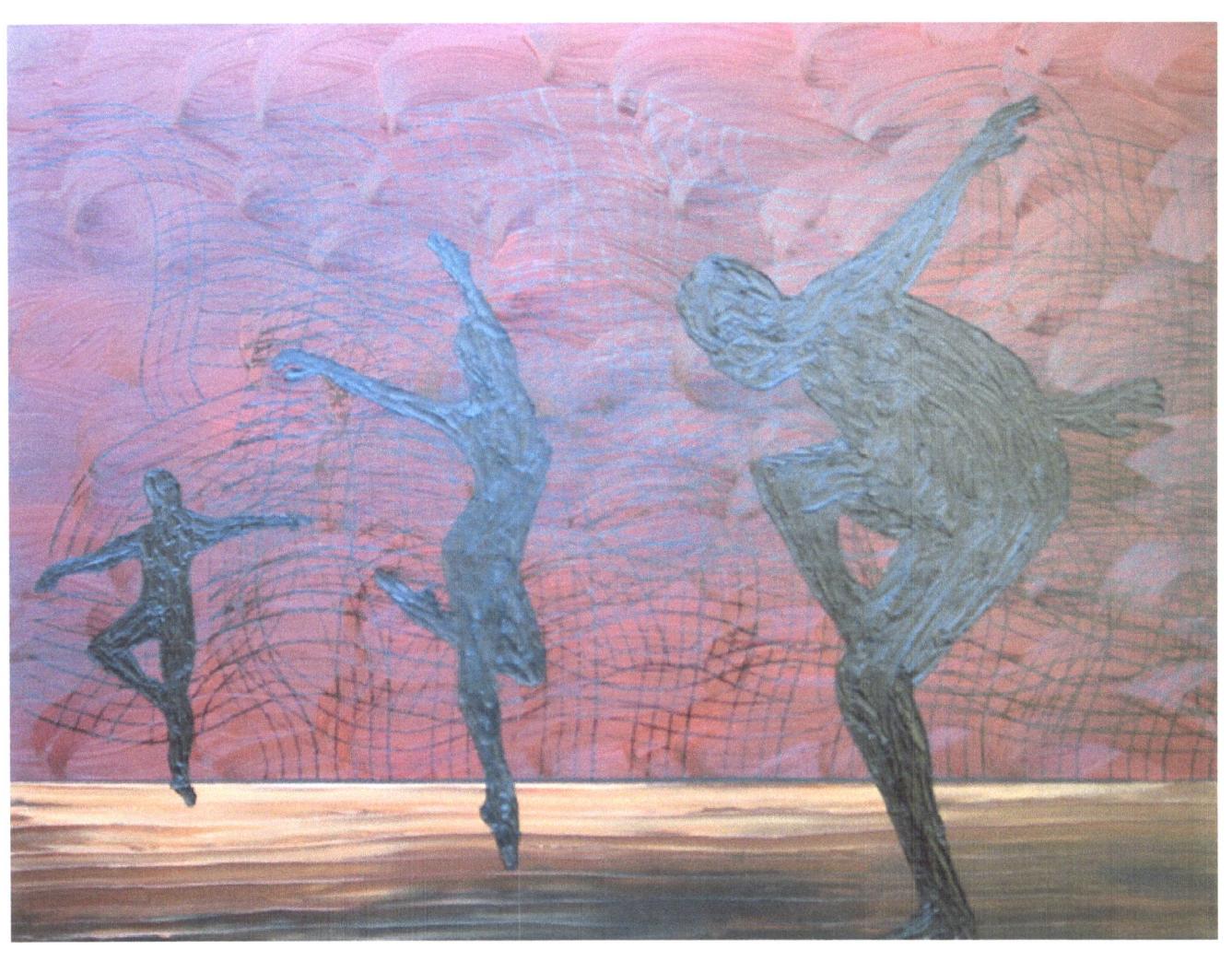

Dancer's Web, 2003
Oil on canvas
56 x 48 in.

BallooningatDusk

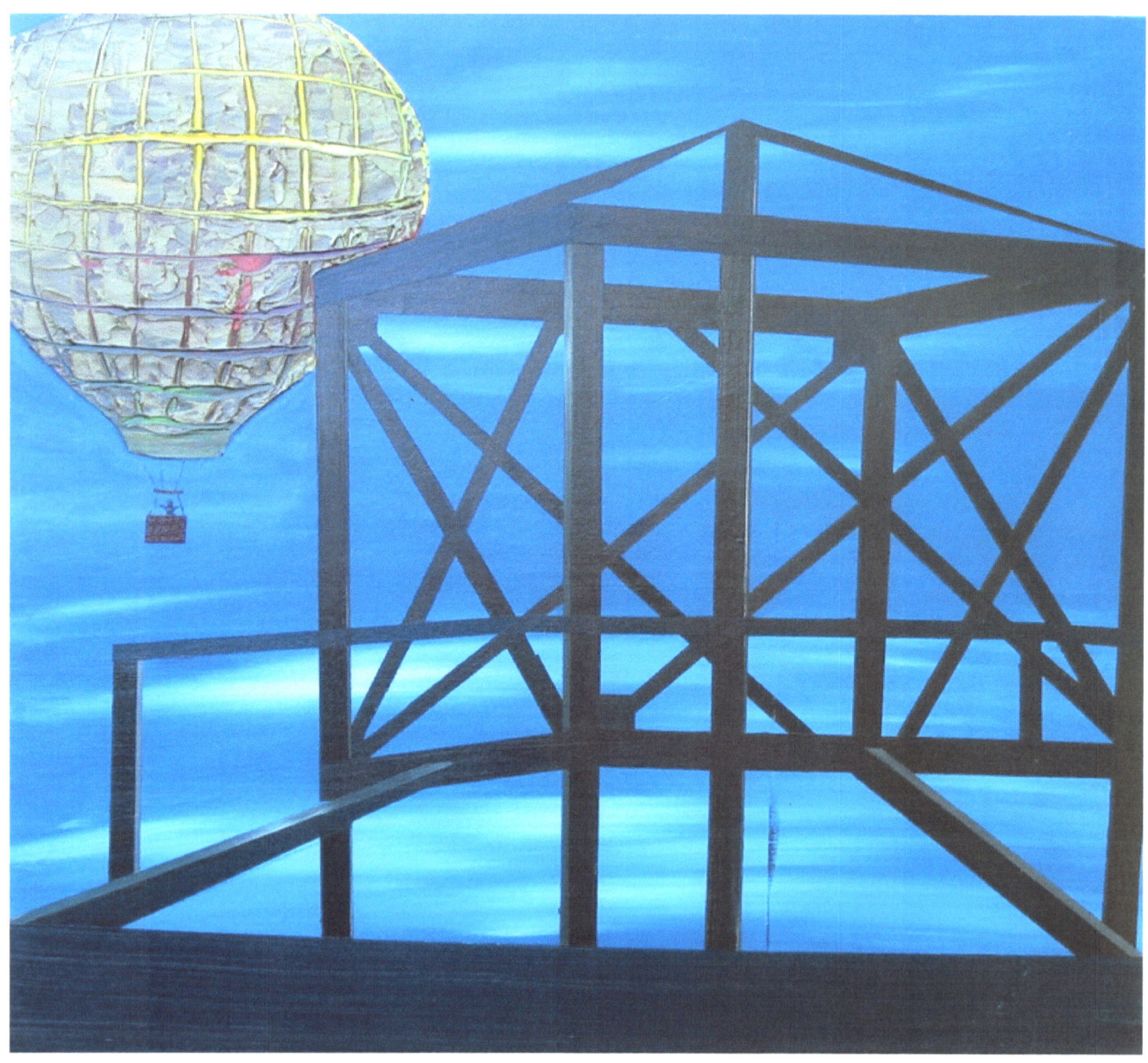

Air Traffic, 2002
Acrylic on canvas
54 x 40 in.

SPACE CAVERN

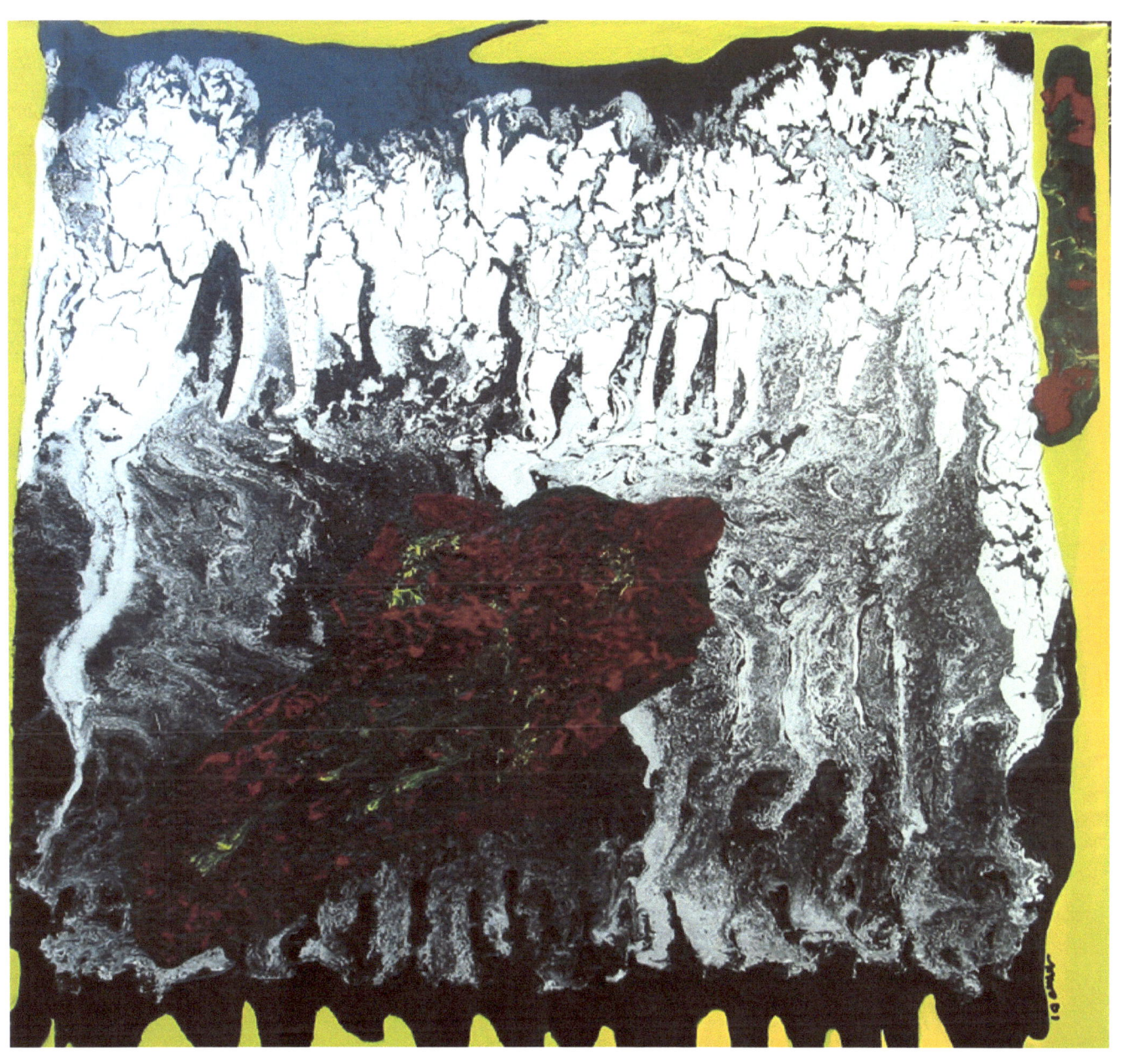

Cavern (Heart), 2001
Acrylic & enamel on canvas
51 x 48 in.

DANTE'S TRAIL

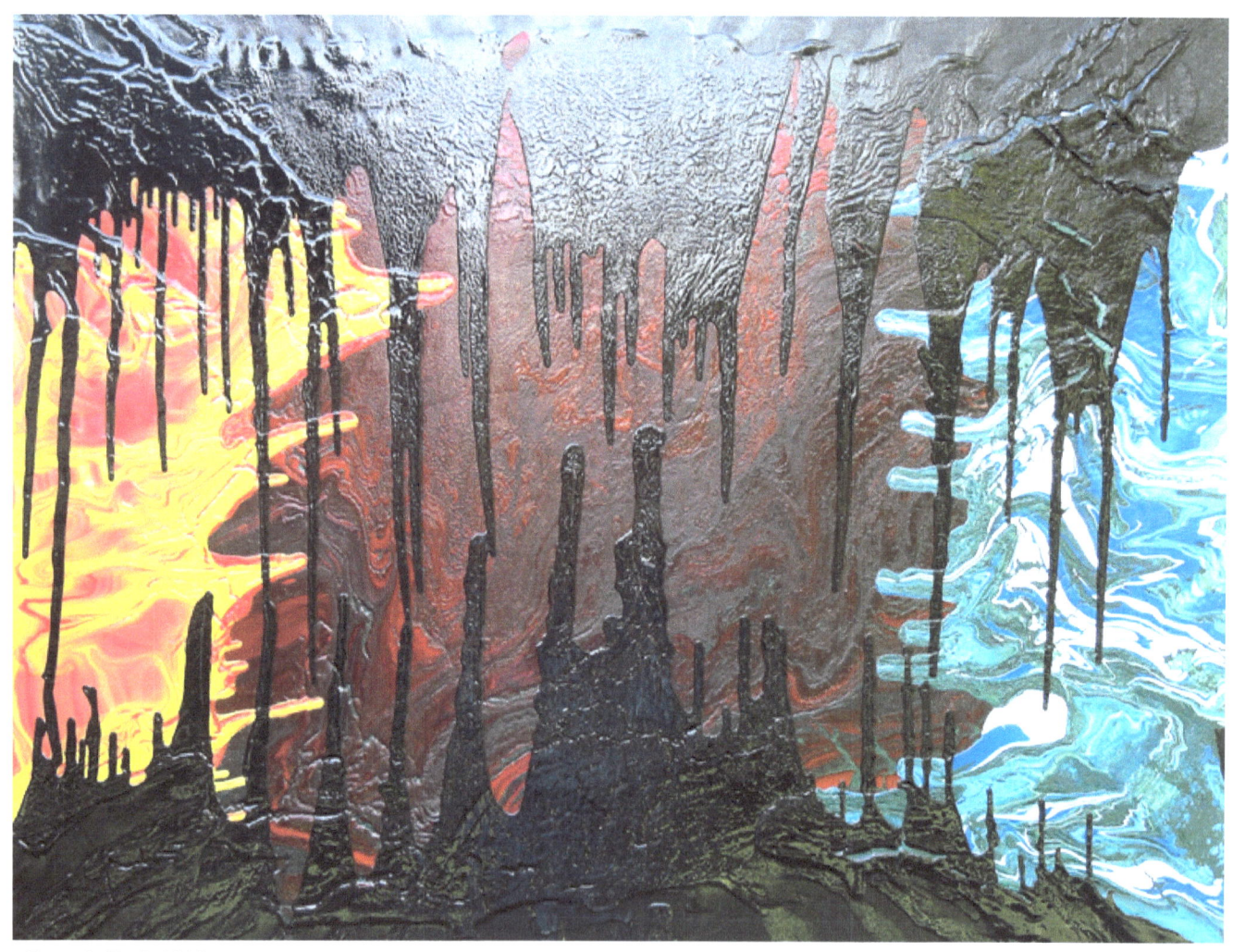

Dante's Trail, 2002
Acrylic and enamel on canvas
72 x 58 in.

GLASS SPACES

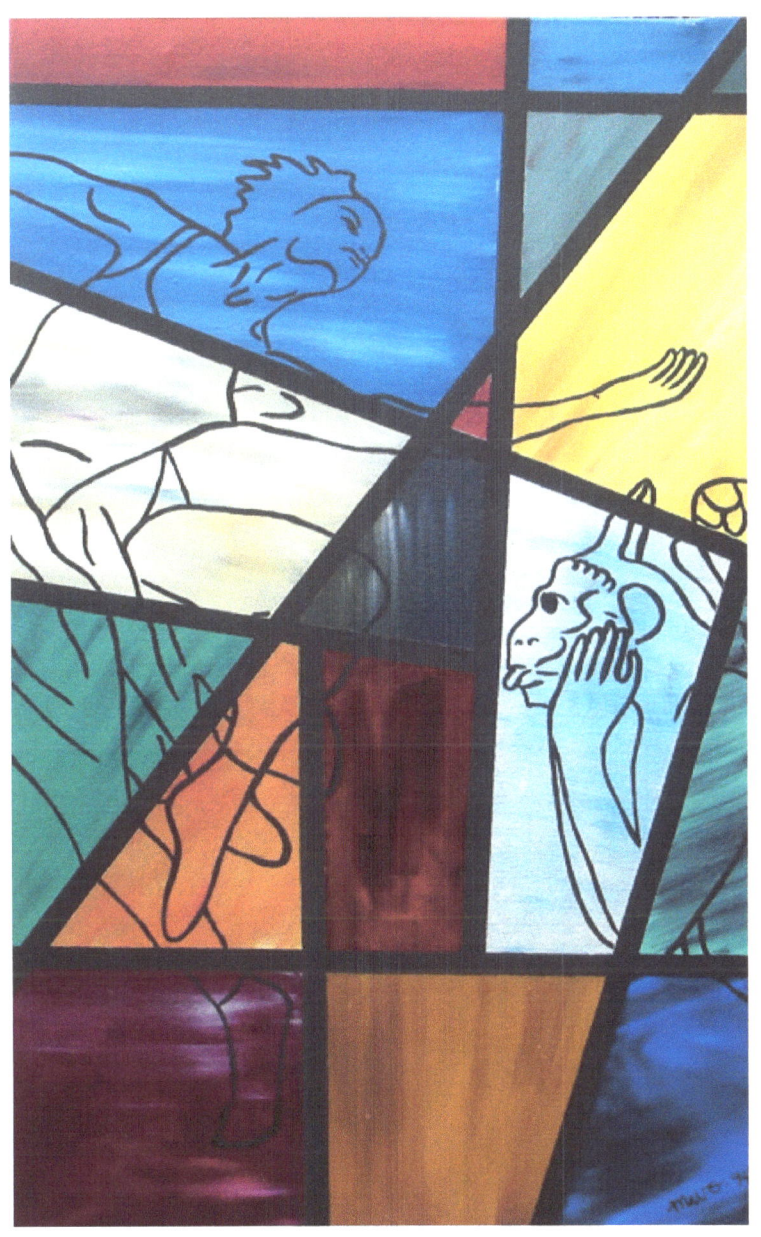

Glass Spaces, 1994
Acrylic on canvas
40 x 22 in.

At times like this the door comes a knocking and messing with my head. And my thoughts are out cropping; tunnels cleared through and out come heads a popping—so I'm about through and these words are just glass spaces.

The mowers in the basement standing on its own—so I'm in the nursery pounding out this poem. The keys are not sticking from the Coke poured out of hand, but the words are still slicing like a split bottle in the sand.

The sounds of a wooden sea form an upright portrait of me; blades of glass are being mowed; my random thoughts are being sowed; and thanks out loud for mysteries not yet met, than if the giants are running to take that bet—so I am hoping that the next dream will see, what the hell it is that I'm supposed to be.

I too took that bet, and I'll be damned if the margin was met. Seldom is seen a portrait so real, that I have been captured with so much appeal—thus damaging my ego, my id and my zeal; thanking them quite loudly right after my appeal; now that they have realized these words of pure steal.

Bittersweet they will stand and will stare, as I sit here writing bottom down I am bare. My jazz is quite handsome with caring so adept—so this fortune's a ransom I get it, I'm in step with the forces of evil a parting I did make, and the fact that I am still writing is just your big mistake.

So publish me before my next big whine; publish my self portrait; pull me off of this great vine; publish my self portrait.

The Elephant Walk

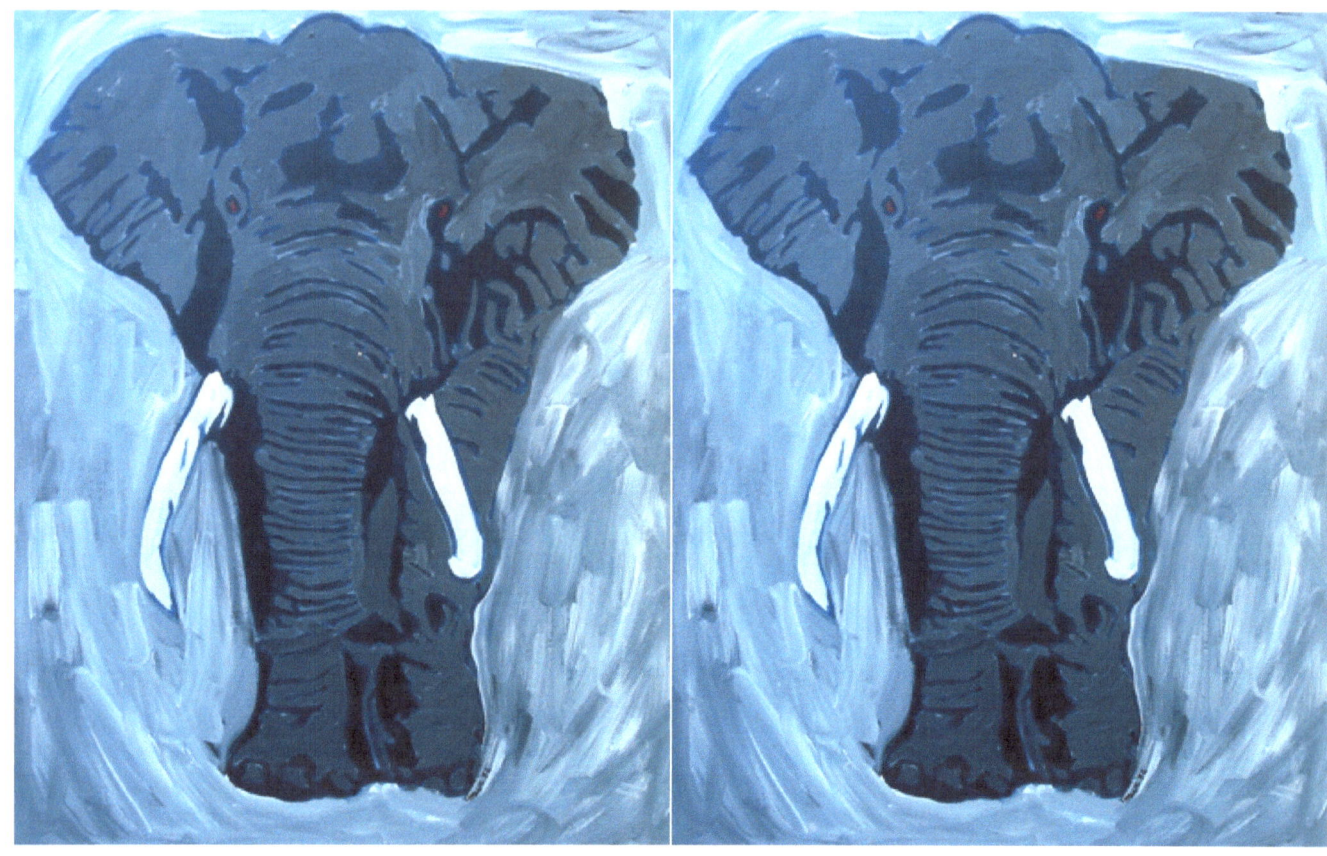

Elephant Walk, 2002
Acrylic on canvas
58 x 52 in.

In a hell painted with a sky so blue and the earth a parched and sandy brown, we are reminded that the natural color of conservation can be violently red. The next sunset should remind us that perhaps thirteen thousand years ago elephants walked their walk to the end of the game on a peninsula that now bares so little life unless we look closer.

What is today considered a beach walkers Mecca, was once considered an instinctual path from life's end to death's beginning followed like the next sunrise. When we reach the wet, darker sands of the beachhead that divide the water from the earth, and the day from the night, the odor of spent life astounds us. But we will turn toward the all-enveloping safety of the inner shore-line one and one-half hours before it gets darker.

The End of the Game

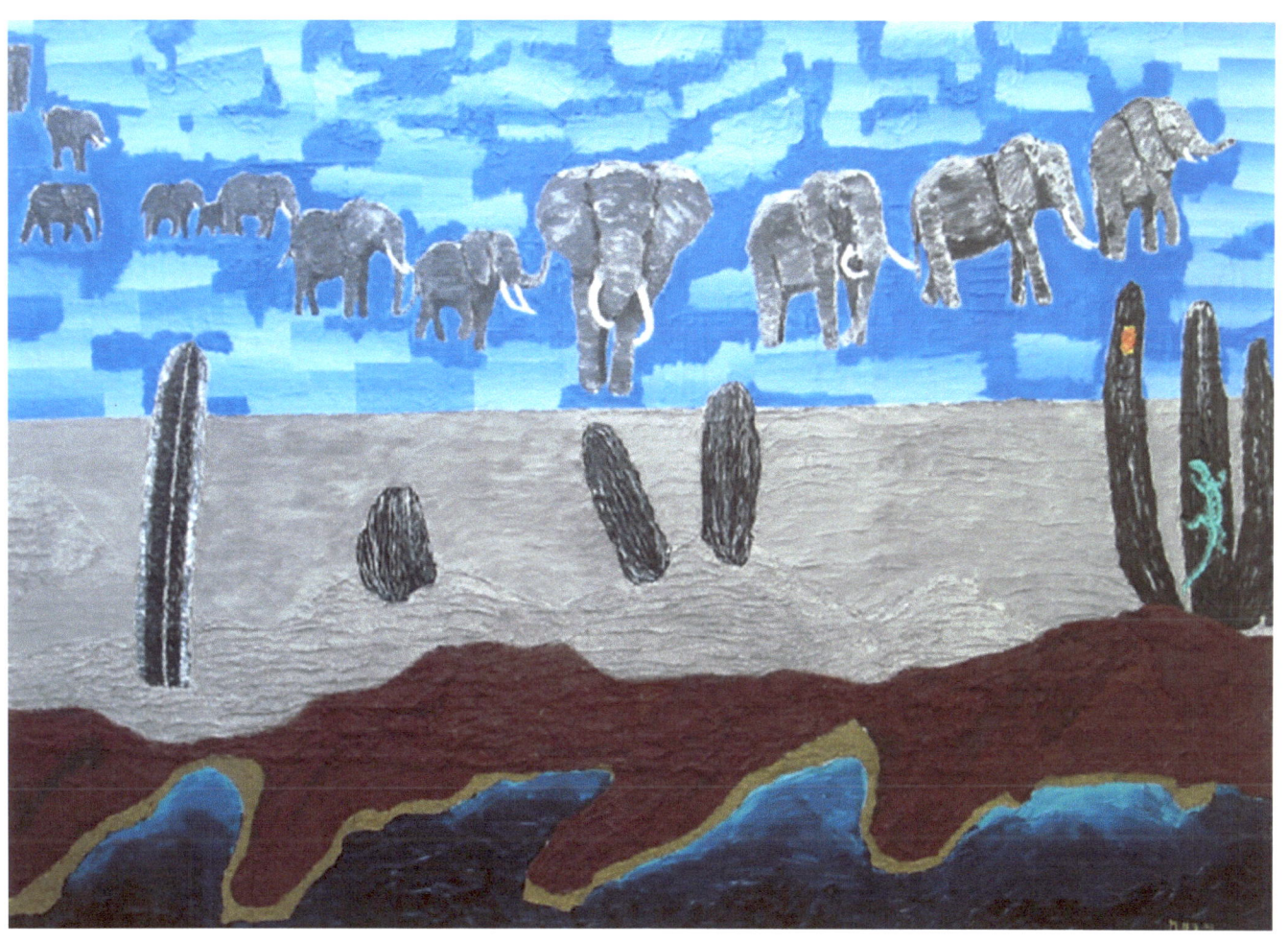

End of the Game, 2003
Acrylic and calc sand on canvas
120 x 78 in.

JUNGLE MIST

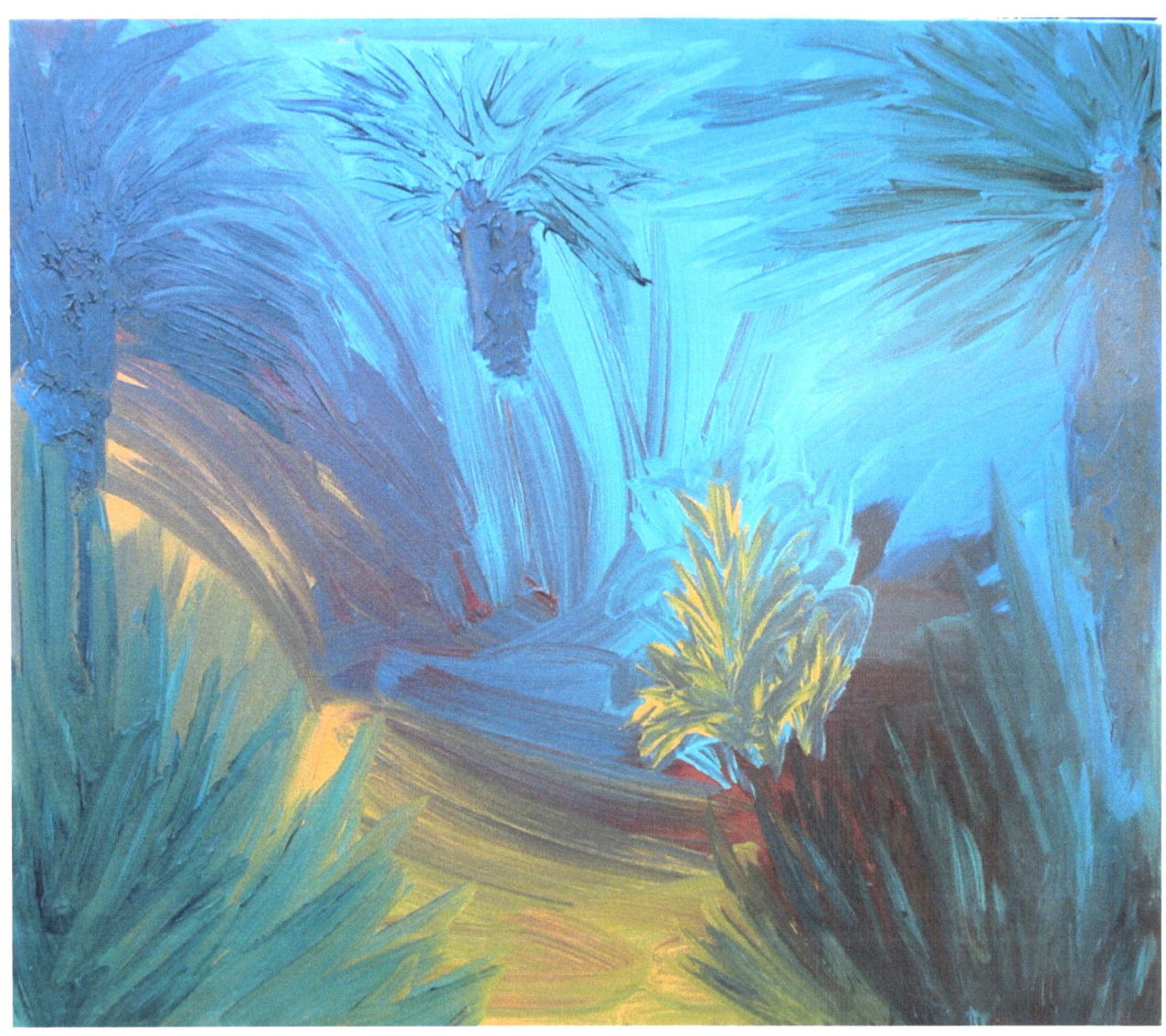

Jungle Mist, 2001
Acrylic on canvas
72 x 63 in.

JOURNEY'S END

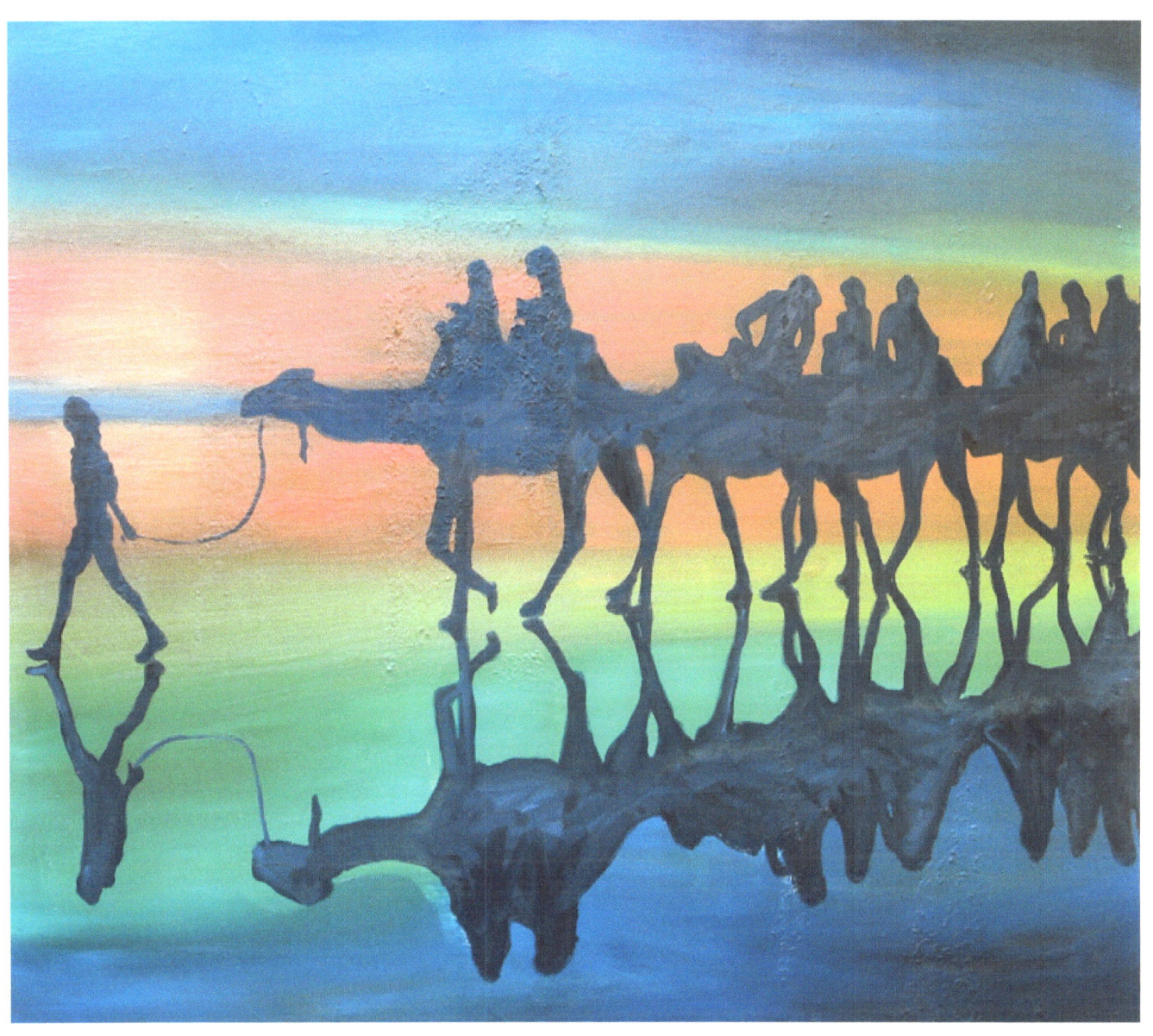

Journey's End 2002
Oil on canvas
88 x 77 in.

Let the Walls Come Down

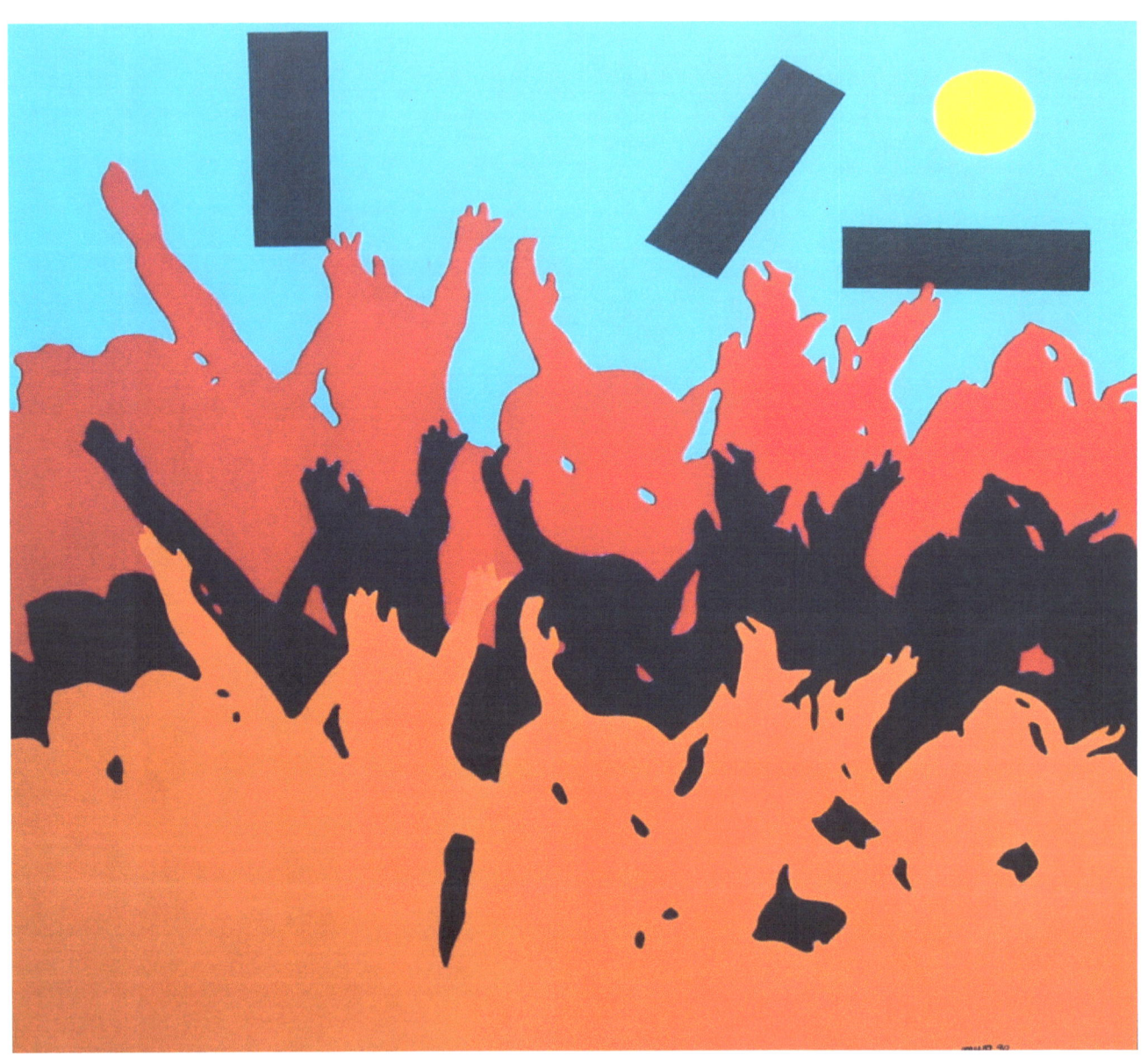

Let the Walls Come Down, 1990
Acrylic on board
68 x 64 in.

MAVERICK'S

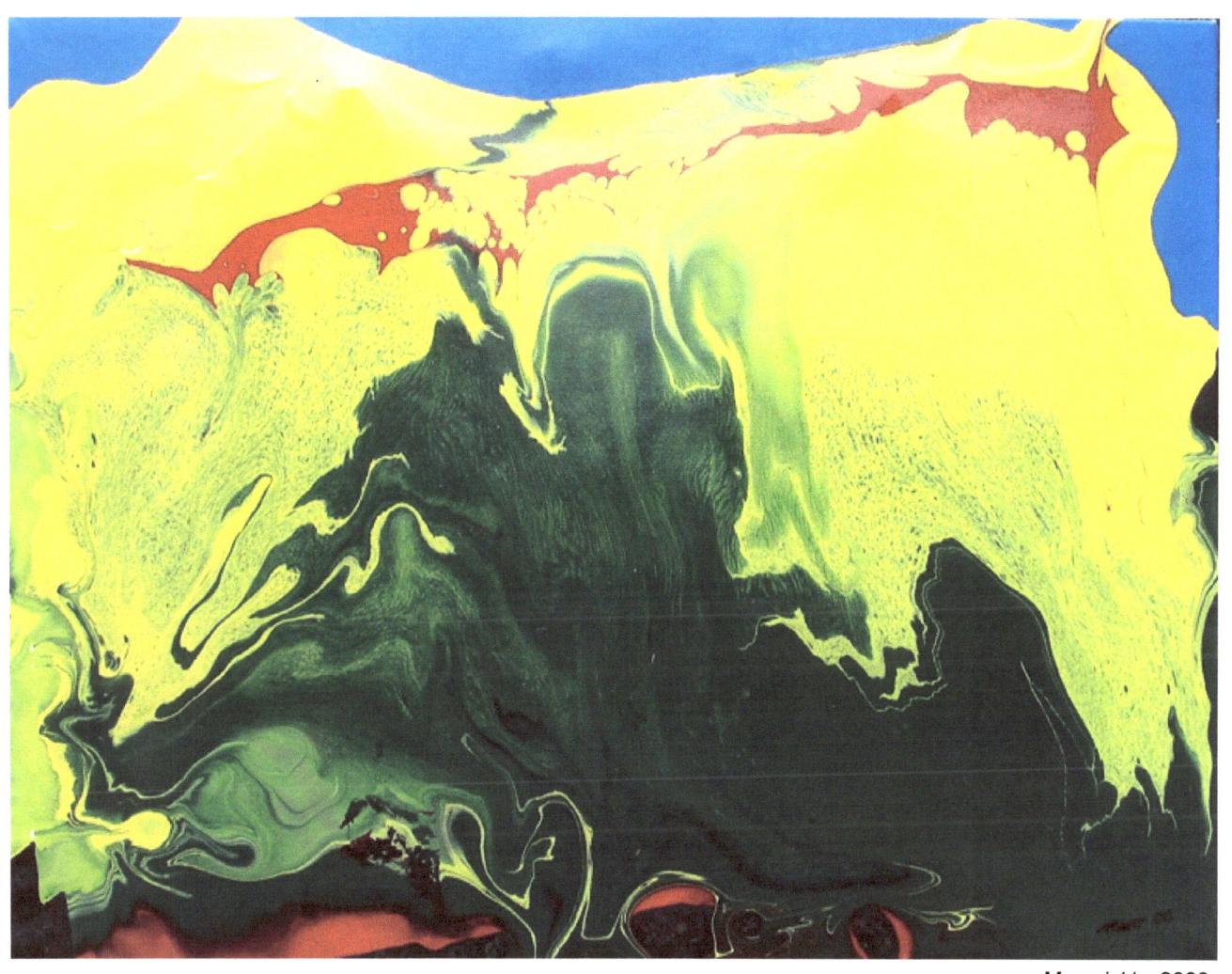

Maverick's, 2000
Acrylic & enamel on canvas
64 x 54 in.

SUSPECTS

Now the interesting facts that arises out of these circumstances, is that awareness of these unpleasant experiences usually leads the viewer to some sort of politically correct solution to the questions they excite.

So is Gumby regarded as an absolute and inevitable consequence of pessimism in modern art? Is he aware of this and does he want to be free of this bond?

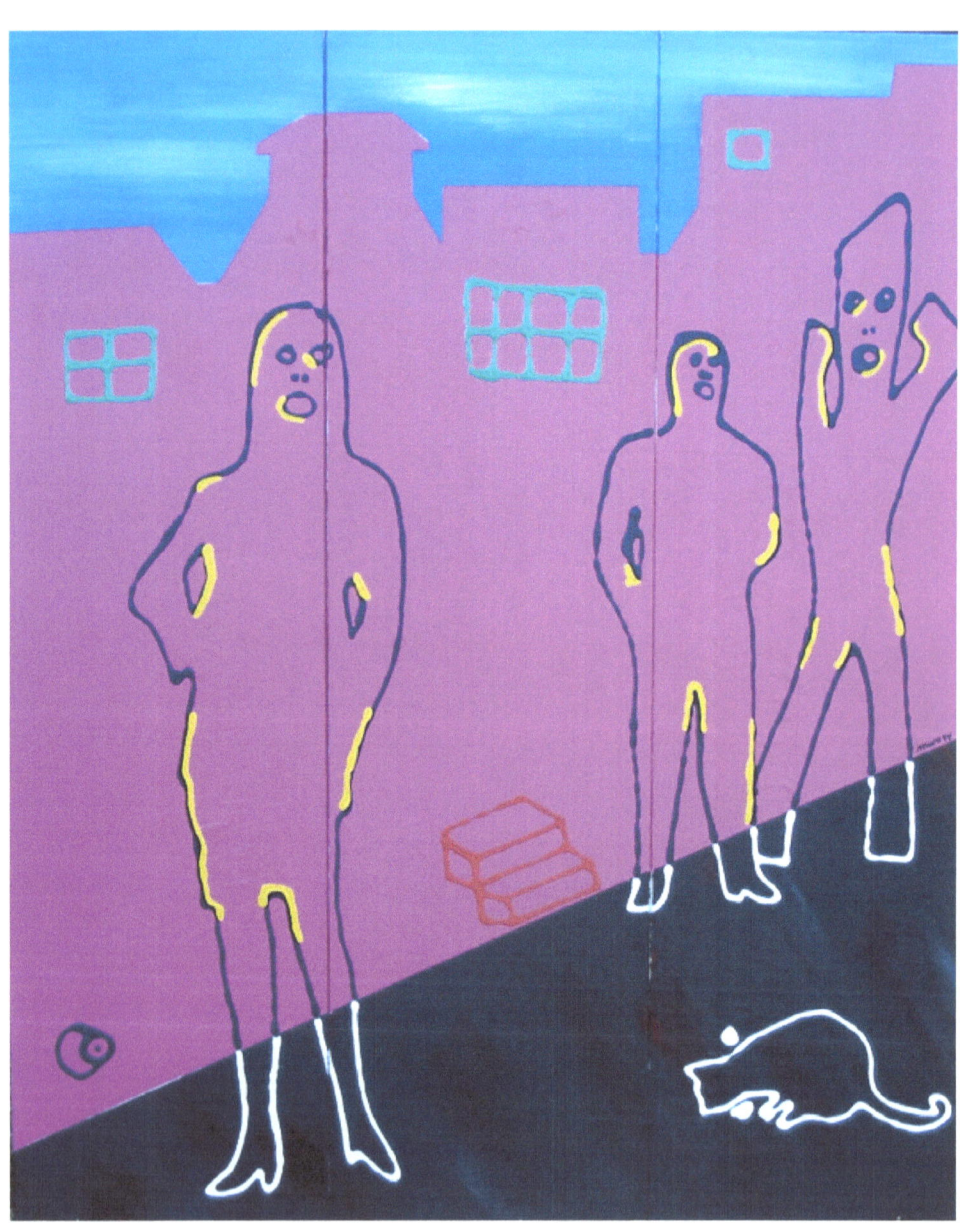

Suspects, 1999
Acrylic and alum power on board
42 x 41 in.

RAIN (Under the Umbrella)

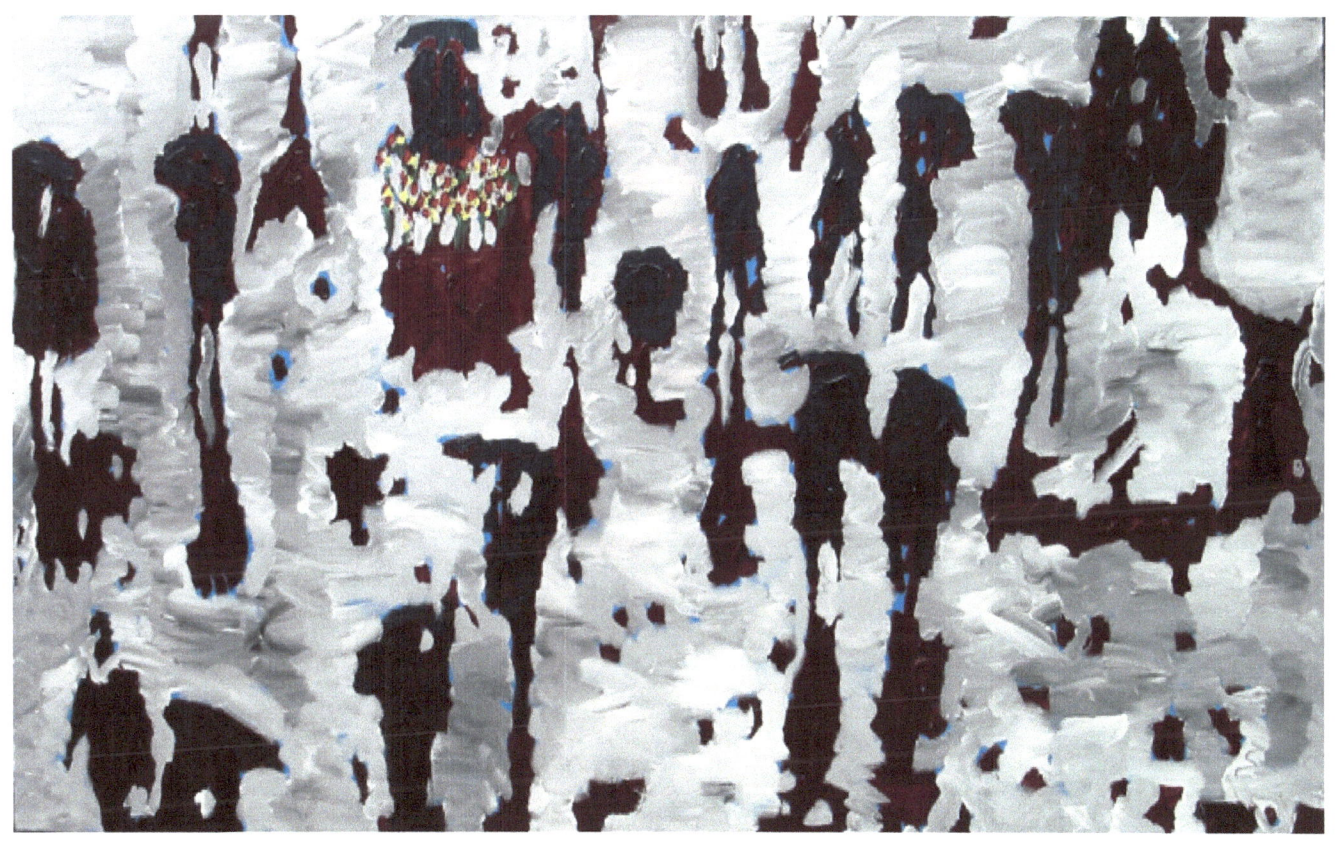

Rain, 2001
Acrylic & oil on canvas
72 x 64 in.

Tightrope

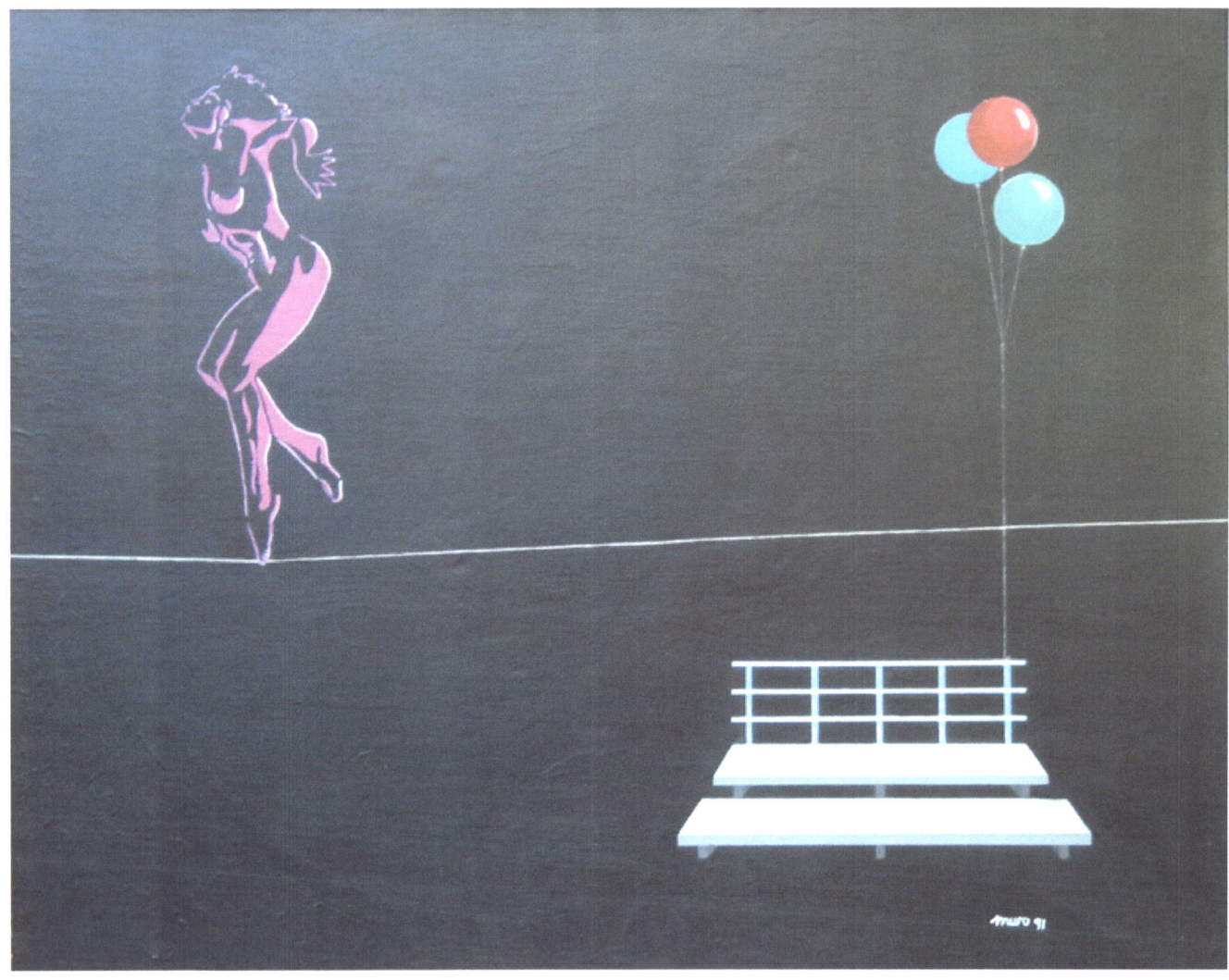

Tightrope, 1991
Acrylic & oil on board
52 x 40 in.
Left facing page

Trapped

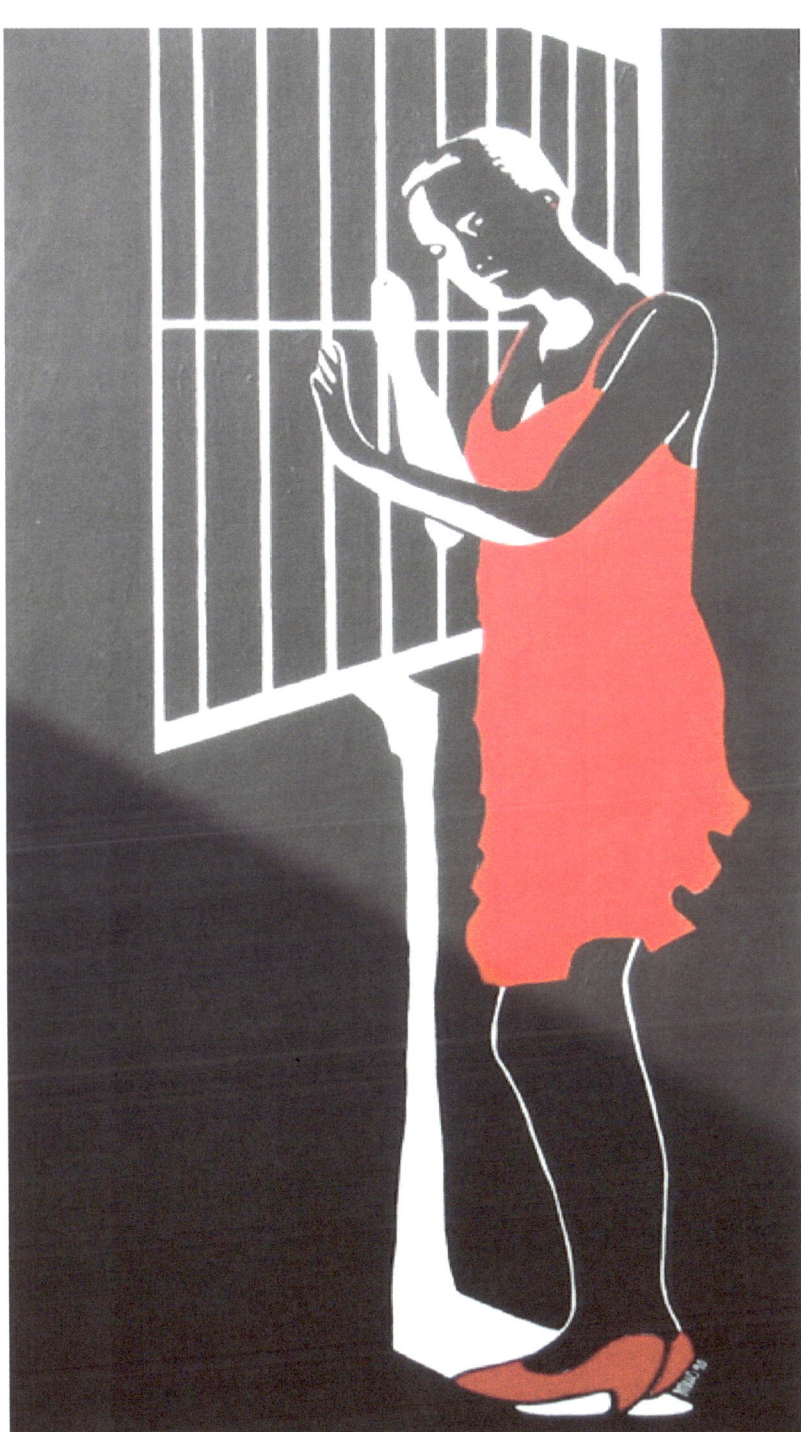

Trapped (in Red), 1990
Acrylic on canvas
60 x 48 in.

WOVEN-MOMENTS

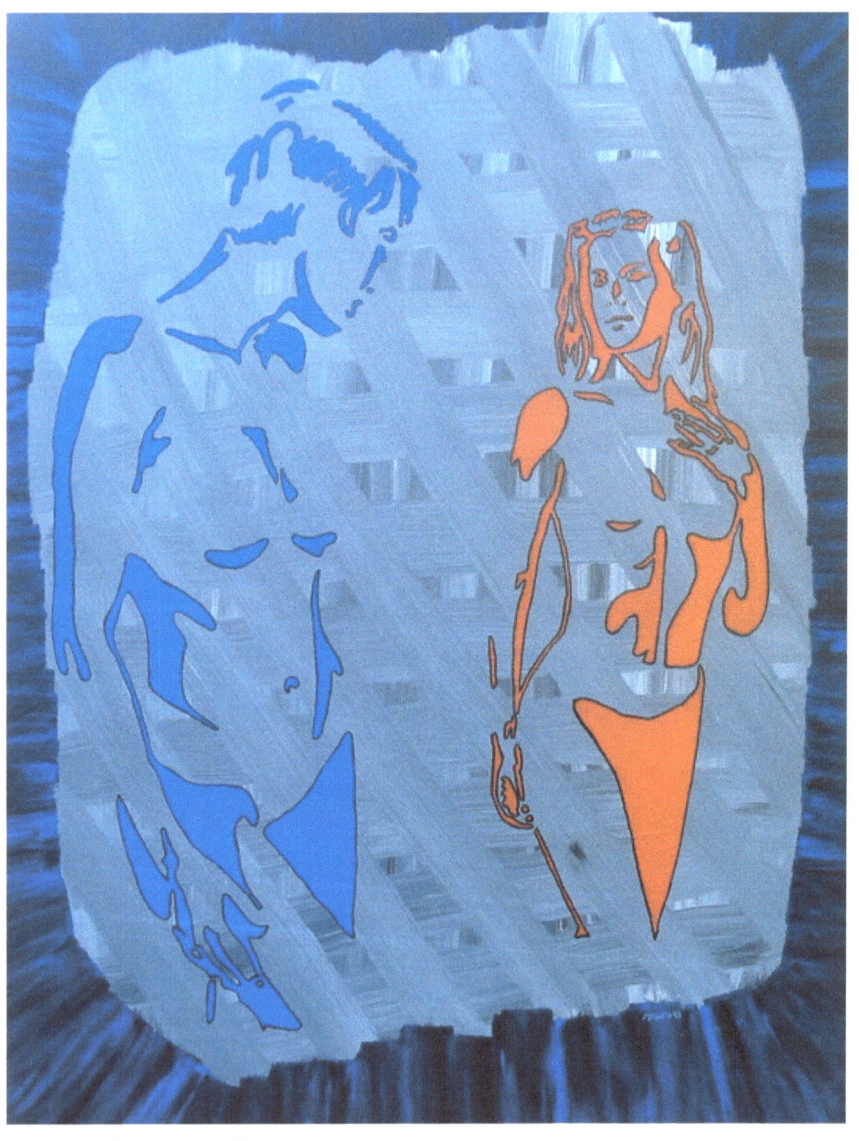

Woven Moments, 1991
Acrylic on canvas
52 x 48 in.

As she studied the movement of a friend from across the room she knew then that her spirit and collective conscience was more than willing to pursue that inevitable next step. It was legend in her own mind on such matters. She would be compelled to express her true feelings for the other, and stop this pretending not to be taken in by the intense and completely satisfying perceptions and sensations that they had just passed to each other. They were in fact locked into each other in spirit, mind and most certainly in body; woven to such a degree that there was no real sense of separateness—so they were like this grand old couple sculptured into a walled relief. The Greeks were not the only ones who knew how this worked.

ZODIACAL LIGHT

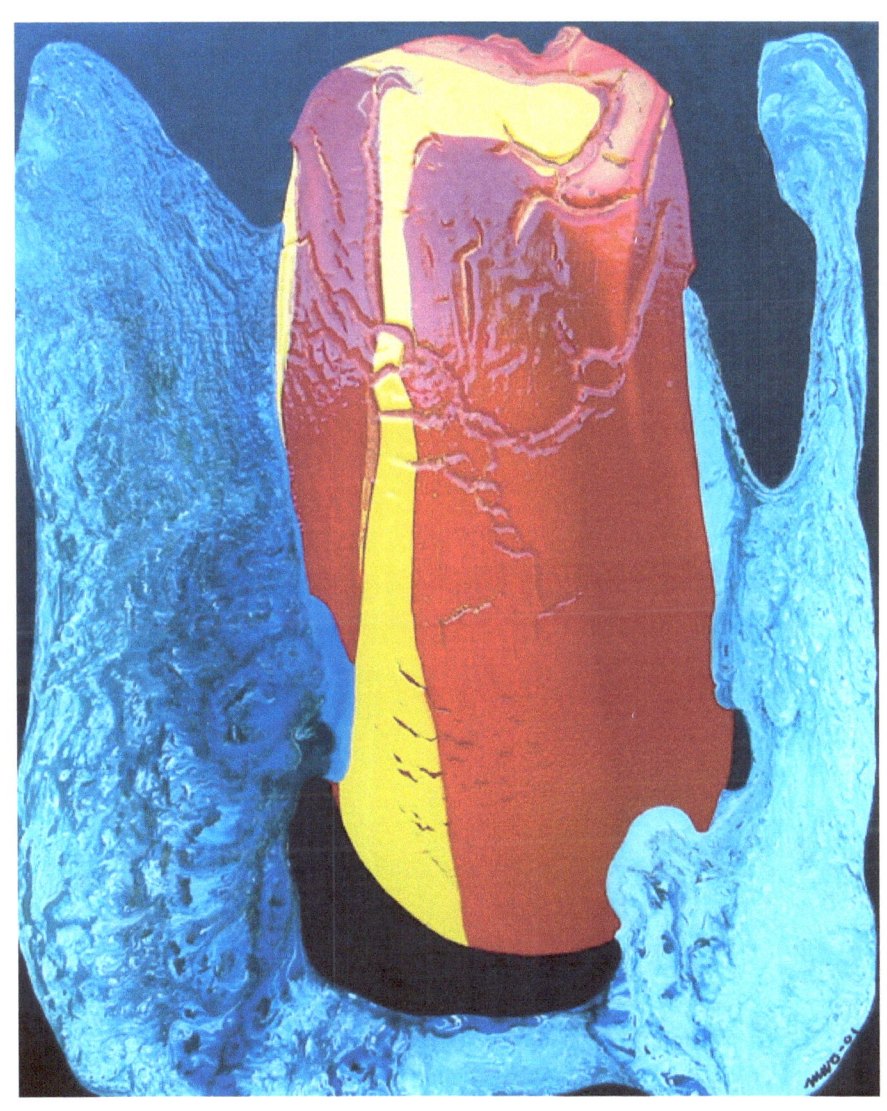

Zodiacal Light, 2001
Acrylic & enamel on canvas
34 x 26 in.

Abandonment

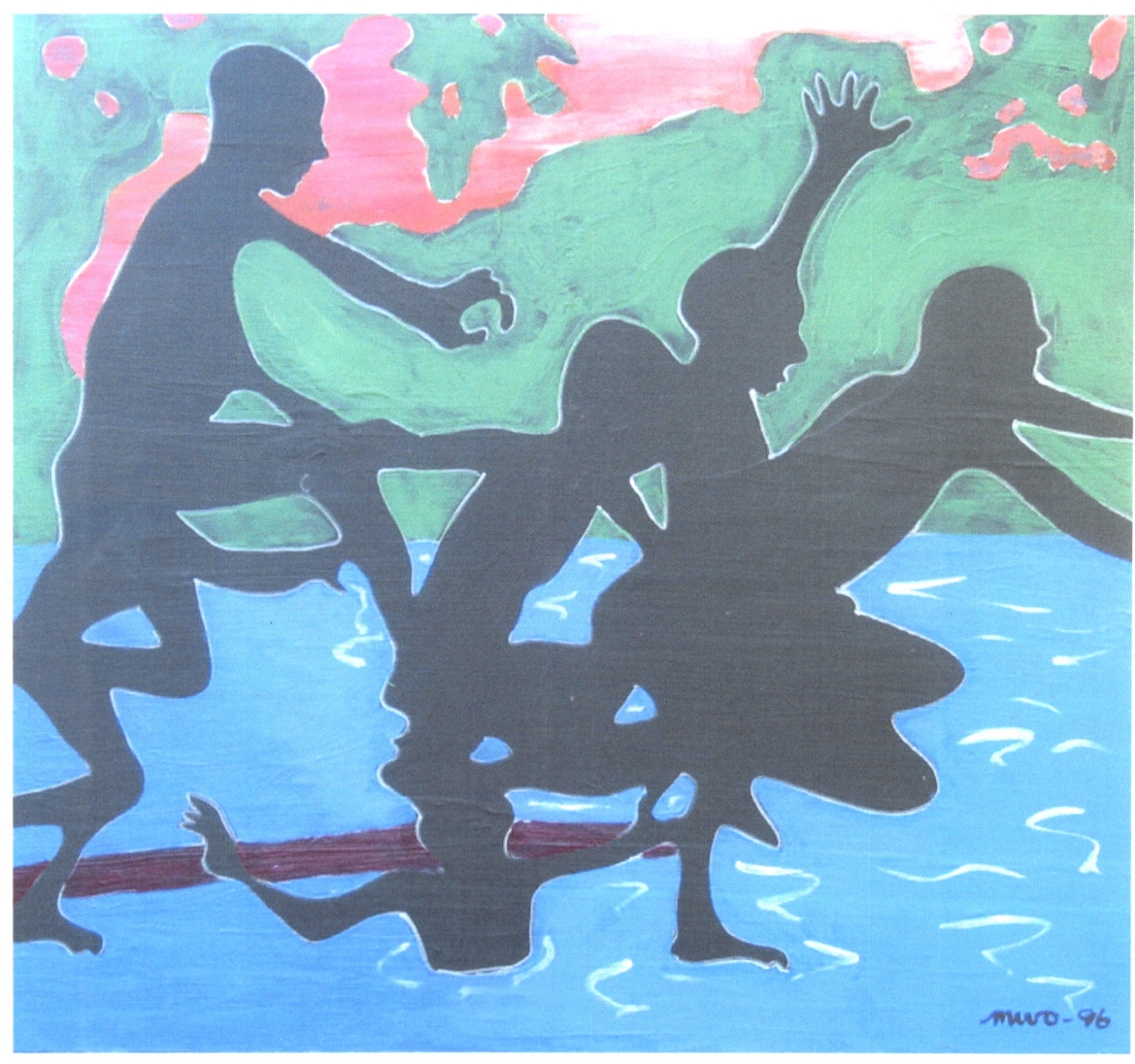

Abandonment, 1996
Acrylic on canvas
47 x 44 in.

Cultural Clash

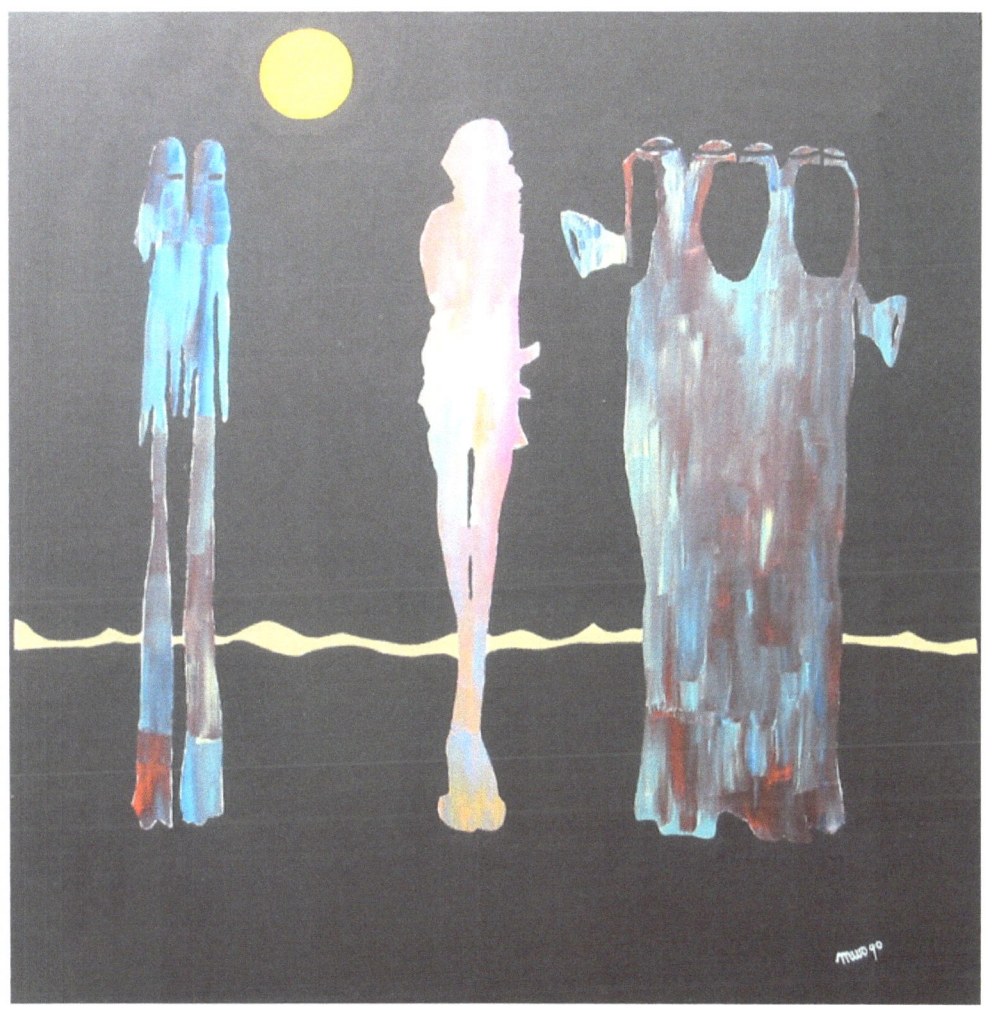

Cultural Clash, 1990
Acrylic on canvas
34 x 30 in.

FACE IT

BROKEN

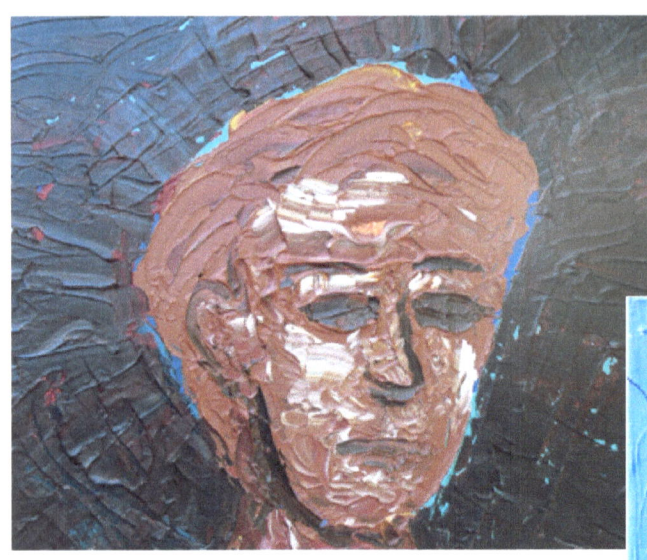

Face It, 2003
Acrylic and oil on canvas
30 x 24 in.

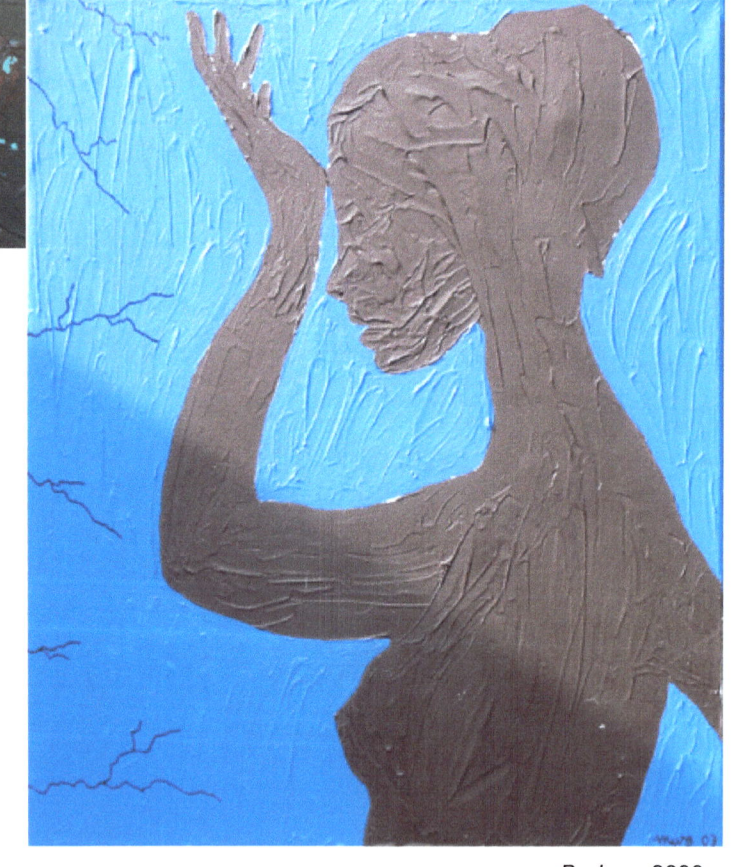

Broken, 2003
Acrylic & oil on canvas
34 x 26 in.

NEON BLUE

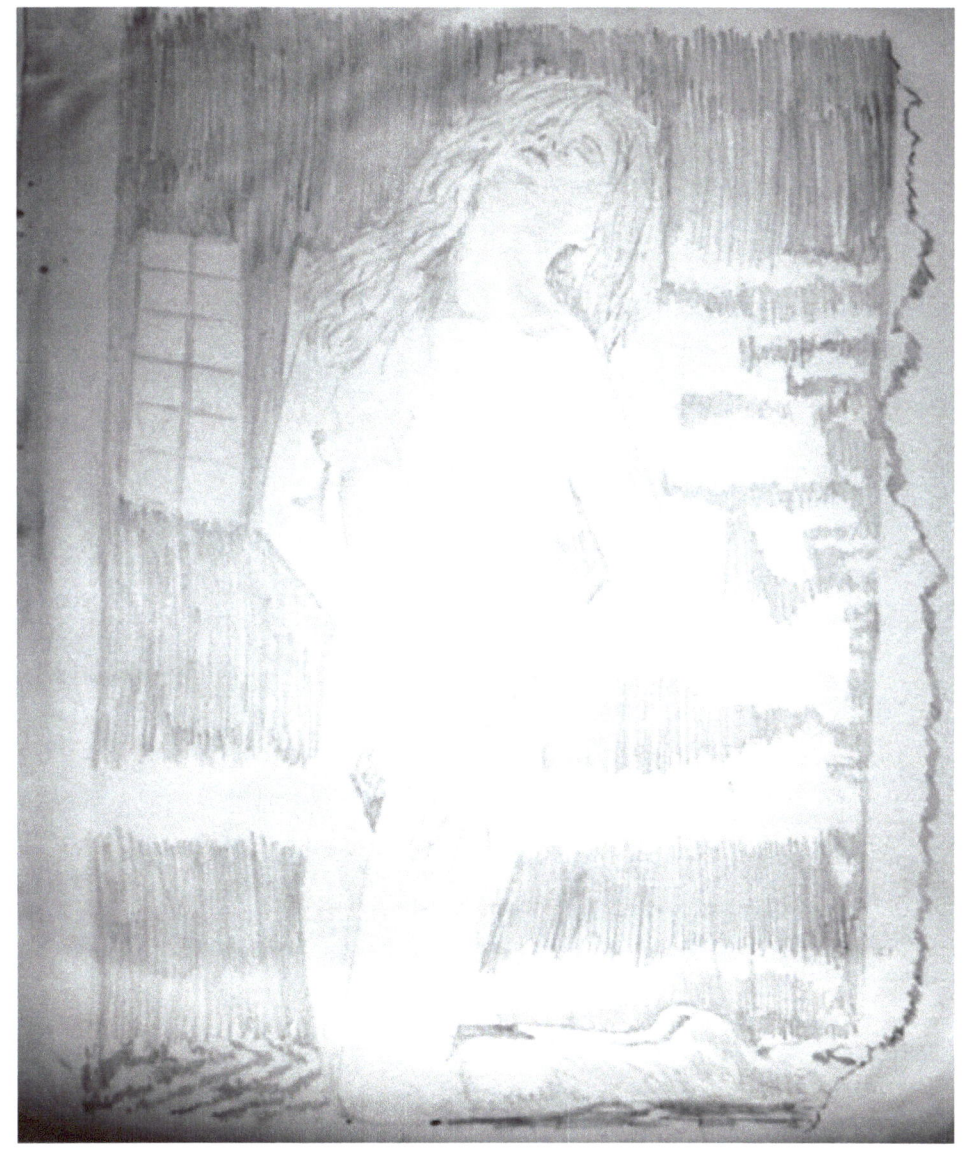

Neon Blue, 1998
Graphite pencil on paper
24 x 19 in.

In a tight spot—
No words to spew out
Across the kitchen floor
After midnight,
With a mouth full of cheese,
Fifteen wines and blues to bust
That door off of the foundation of
Some crappy computer nightmare
That slithered and
Gobbled our minds away,
Finally letting us escape
Through the back train roads across Siberia.

Piano gone wrong—
She couldn't do it
But insisted that we try,
Crying abound from within some whim
We found some dandy words
And poured them into a glass,
And got blasted feeling neon blue.
Um hum.

SCREAMING

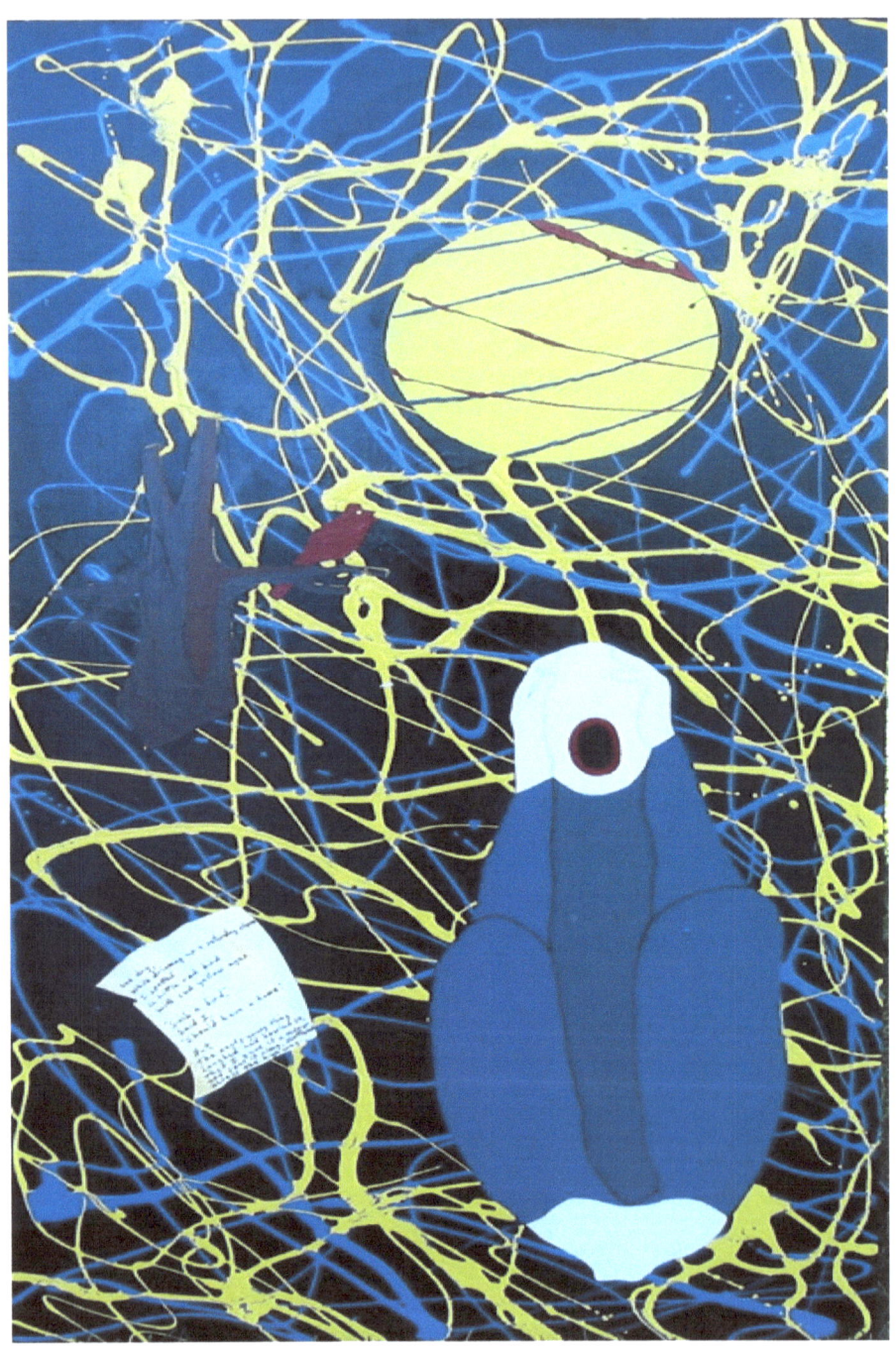

Screaming (Scattered), 2000
Acrylic & enamel on board
59 x 40 in.

Sitting Blue

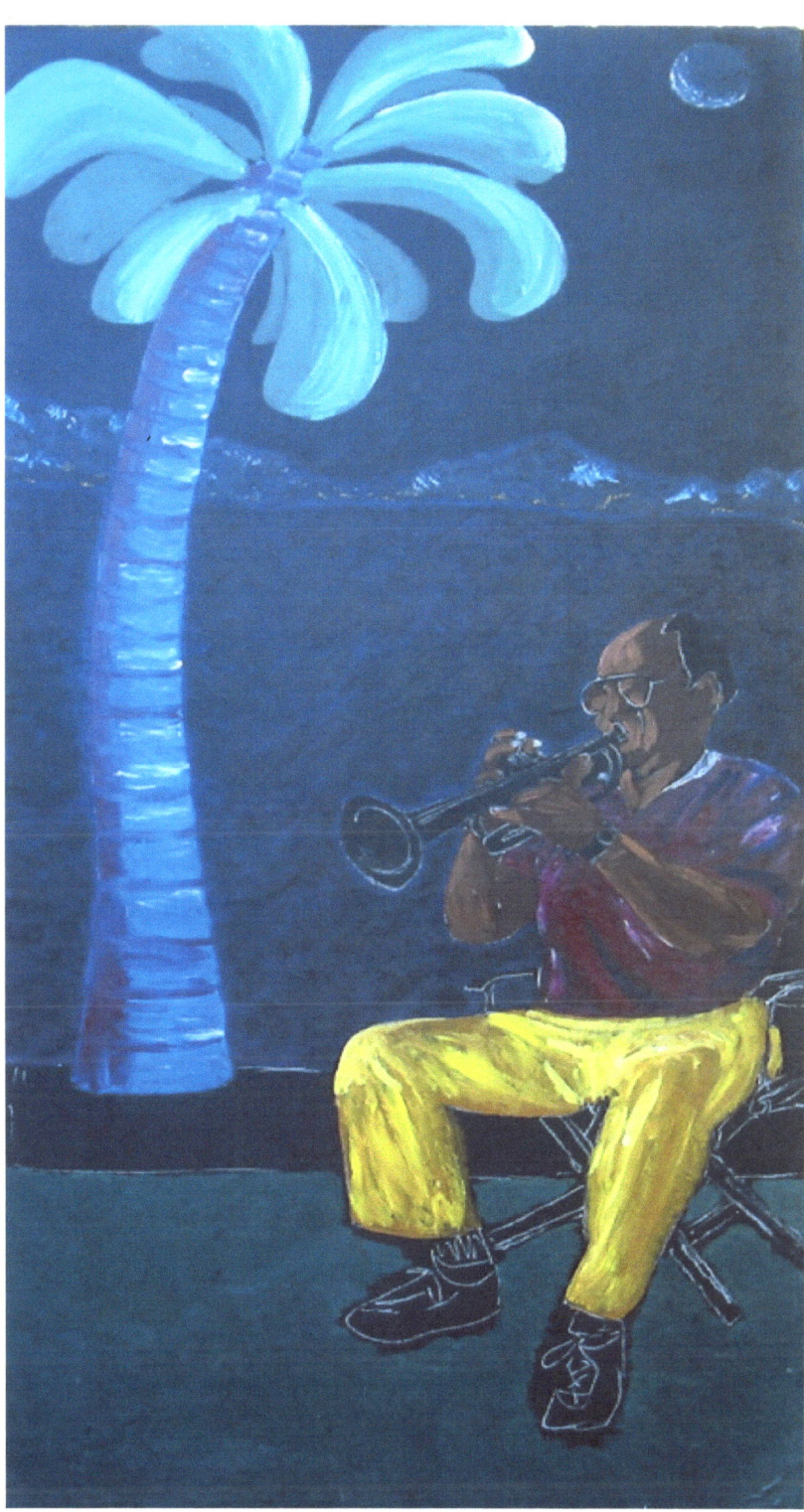

Sitting Blue, 2002
Acrylic on board
72 x 36 in.

Sitting Blue

The Big Man
Was the family champion.
Once bred for pope-hood
Now sits triumphant
With horn in hand; a sharp-edged ax blown just right;
Dreaming of blowing,
Screaming with improvisation,
All that is the blues;
A black man's Mozart;
Played by the blue bay in a place called Burlingame.

It is one o'clock in the morning
In the city that can,
Four days before the New Year—
With changes so vivid
Of the pope
In his distance—
Getting to that birth place of the blues—
Suburban style.

The things that are remembered
Tremendous in their rage,
Must have come
Like all rare dreams
From the mid term
Of middle most upper class families,
Found in the breach of a savage life
In the draft of non play years
And plagued by the getting out
In big black and sleek New Yorkers,
Dodge Darts and VW Bug blues.
Let us party,
Jam and dance
Across the canyons of the Sisters of Mercy.

Decades later someone asks,
"Where did everyone else end up?"
Most landed in never-never lands
Of the orient: The Jewell of the East,
And with big honcho gurus;
The last being Jim's
And the first being John's
Award to the states
Through one additional vote.
And high school friends rode on
And literally off of the Devil's Slide,
To meet that final chapter of loners—
Perverse and perplexed—
Toward the future
Of Kool-Aid ads,
Which require the highest imaginations
To thinking which way is really up?
And in the end only god knows,
Why boredom killed so many of our friends.

The war was good luck
From the black-jacketed bowl rats,
Alleyways,
And the songs that were not meant for the middle class
In the first place.
Nor were the mills,
The warlocks and the righteous,
Philosophers and brethren
And the sick yet talented individuals
Who had the great fortune to escape,
By going directly to the future,
Around love,
Life and breadth
And the Big Man.

Violin makers may survive
But not as well as the musicians,
And the writers and the painters,
And the poets and educated ghosts.
In the end only news reels may supply
Revelation to the off to college brothers
Looking for links to the lower class;
All semantics and linguistics
And the mathematical scores,
And eventually
A deeper understanding of that other man's blues.

The blues were truly born
To save the deepest and widest ghettos—
Black and white—
And beloved on America's highways
And absorbed into lily perspective
None like the fifties,
But all in the name of the sixties,
The seventies,
But the eighties perhaps not.
I cried I never knew the blues
The same way as the Big Man,
And felt for it so breathless,
And tripped for it nevertheless,
The same way I felt for art—
Moved so visually and so wet—
So I just touched it and I reflected
In the same hours of the day,
And I have chosen to be forgiven
For my improvisational way,
My attitudes, values and judgments,
And my reputation.
Because I
Was one of the sole survivors?
And so there I was—
Still alive.

Civil Moments

Reflect

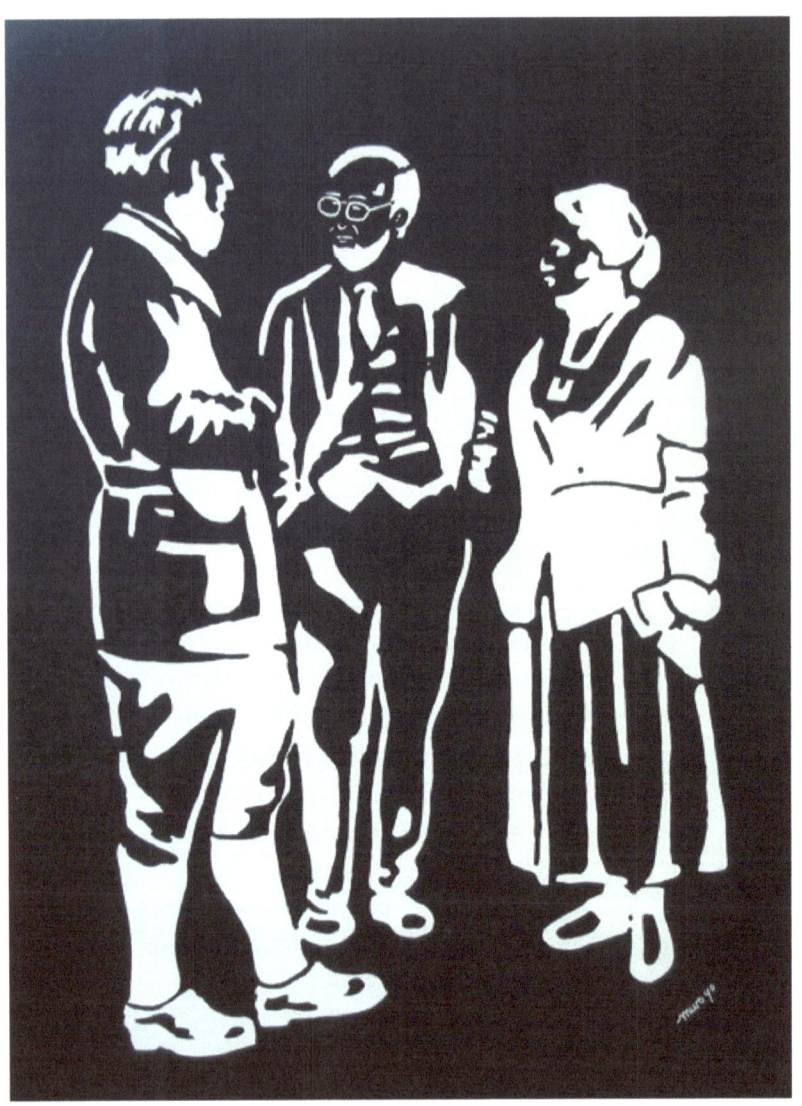

Civil Moments, 1990
Acrylic on canvas
30 x 24 in.

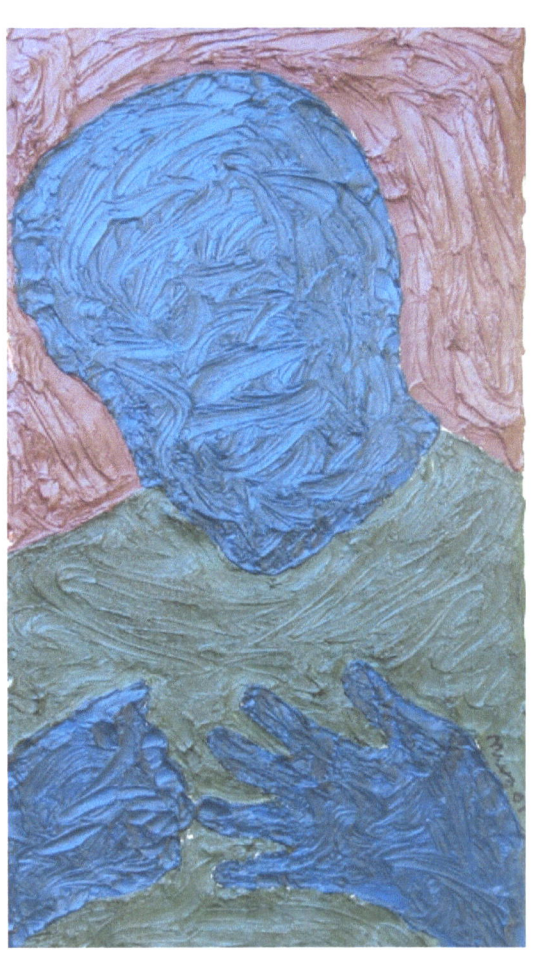

Reflect, 2003
Oil on canvas
24 x 12 in.

Kitty

suffered on her front porch while an old gray dream scratched at the door

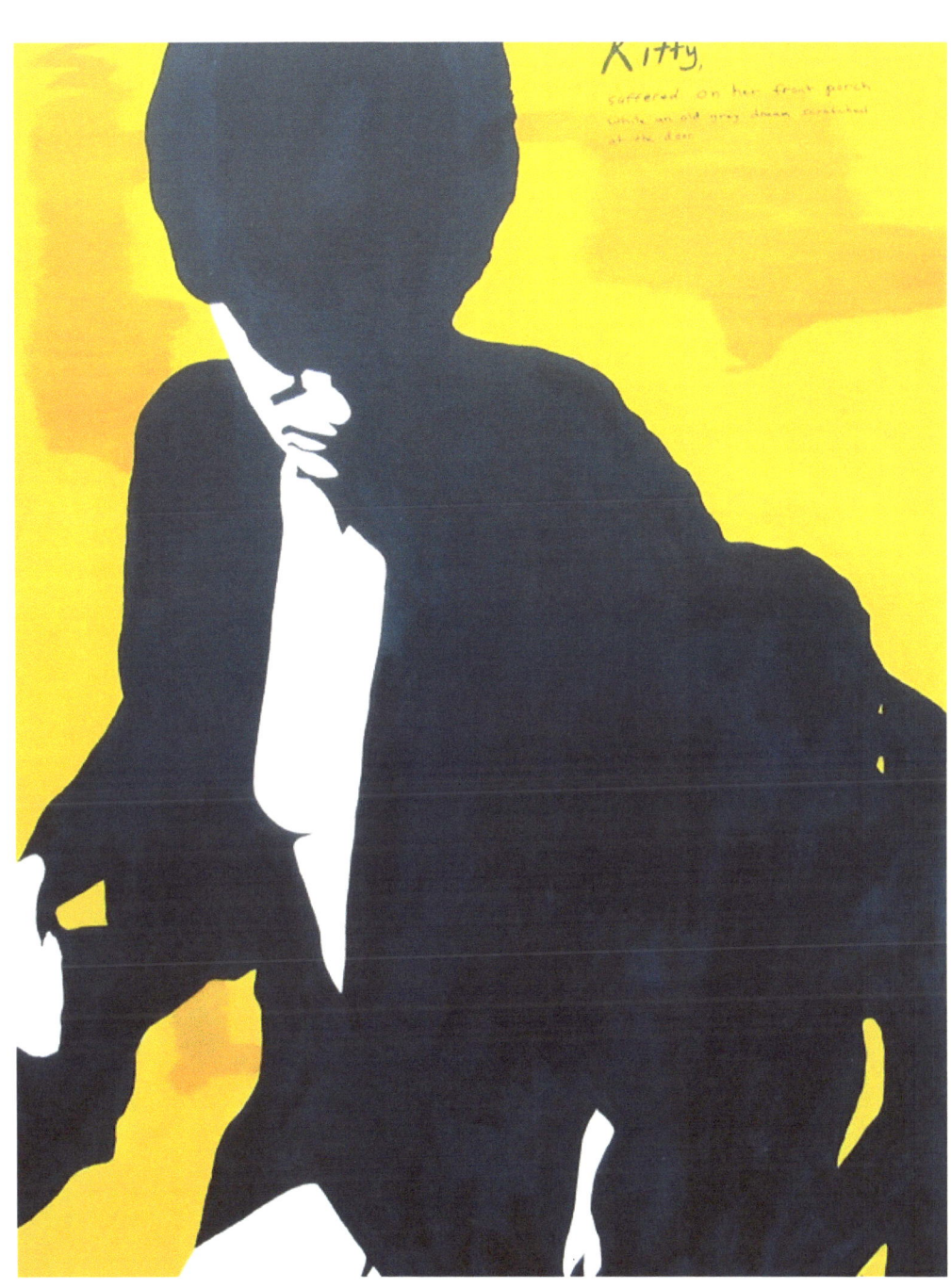

Kitty, 1991
Acrylic on canvas
66 x 46 in.

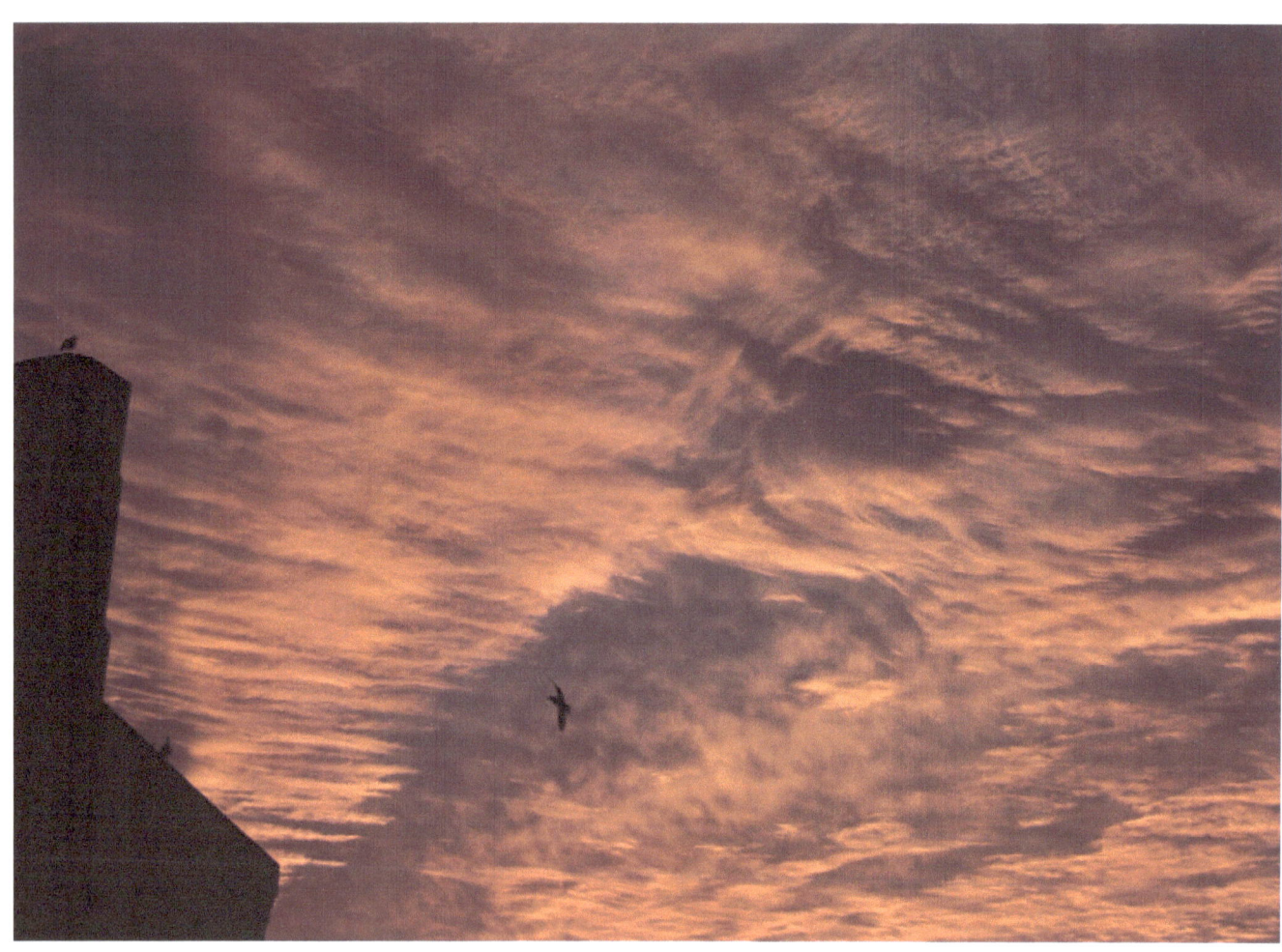

Fireworks, 2001. Photo

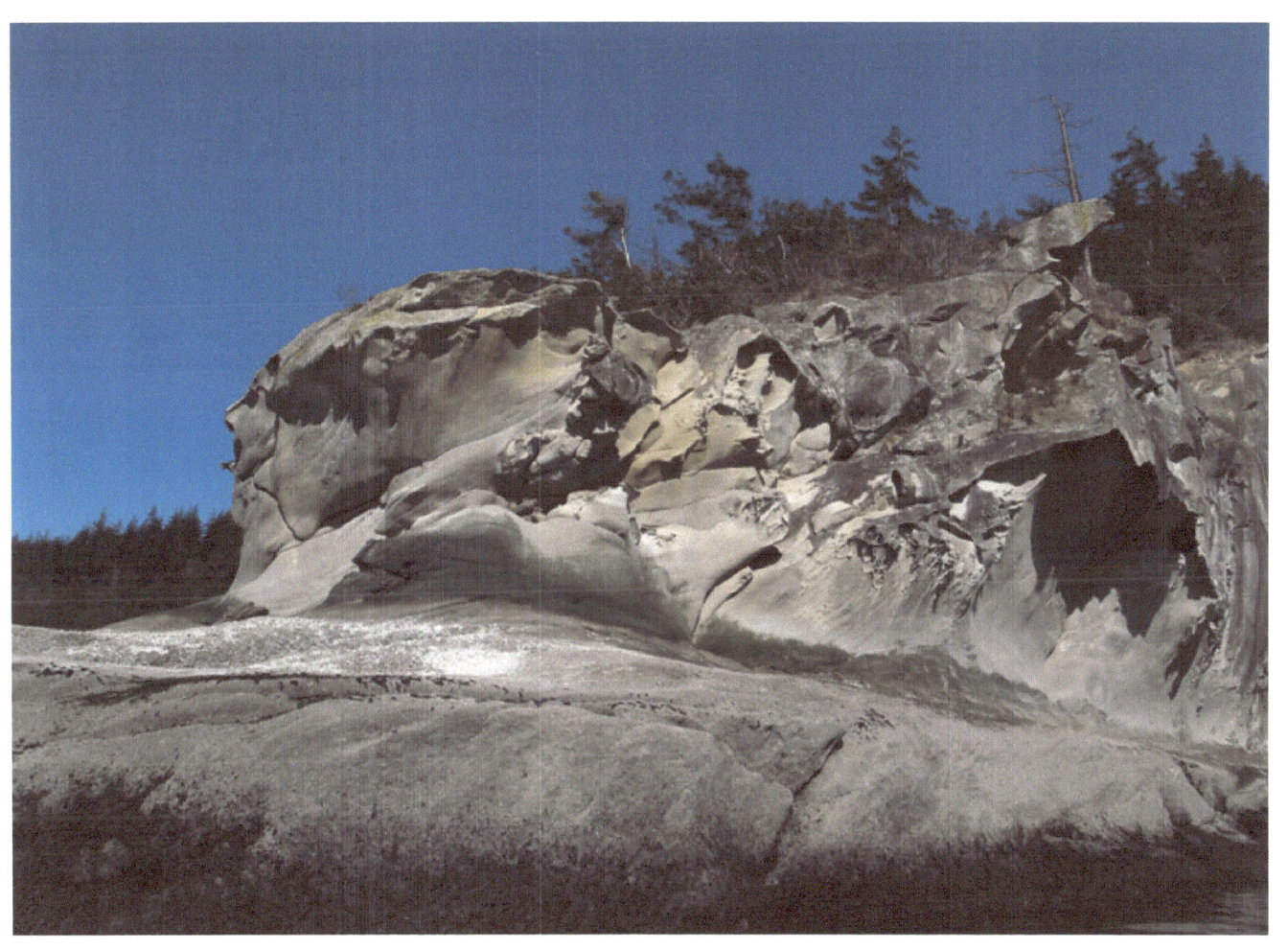

Sandstone, 2001, Photo

For those people who are interested, the paintings on the front and back cover of this volume were created after initially being exposed to the history and perspective of Peter Beard, author of *The End of the Game*, published originally in 1963. Mr. Beard's works focus on the extreme cycles and natural balance of big game in parts of Africa. I was fortunate enough to witness the great strides of the same big game in their natural element during my own visit to Africa in 1998. I am still overwhelmed by the images I encountered, and the photographs I feel privileged to have taken.

During a much different type of expedition to Baja California in 1990, I was exposed to an archeological dig where scientists from Mexico and the United States co-discovered a site rich in the remains of ancient big game. The remains of the site were estimated to be thirteen thousand years in age. Once again I consider my self fortunate and still overwhelmed by the images that I encountered.

<div align="right">Michael O'Connor, 2004</div>

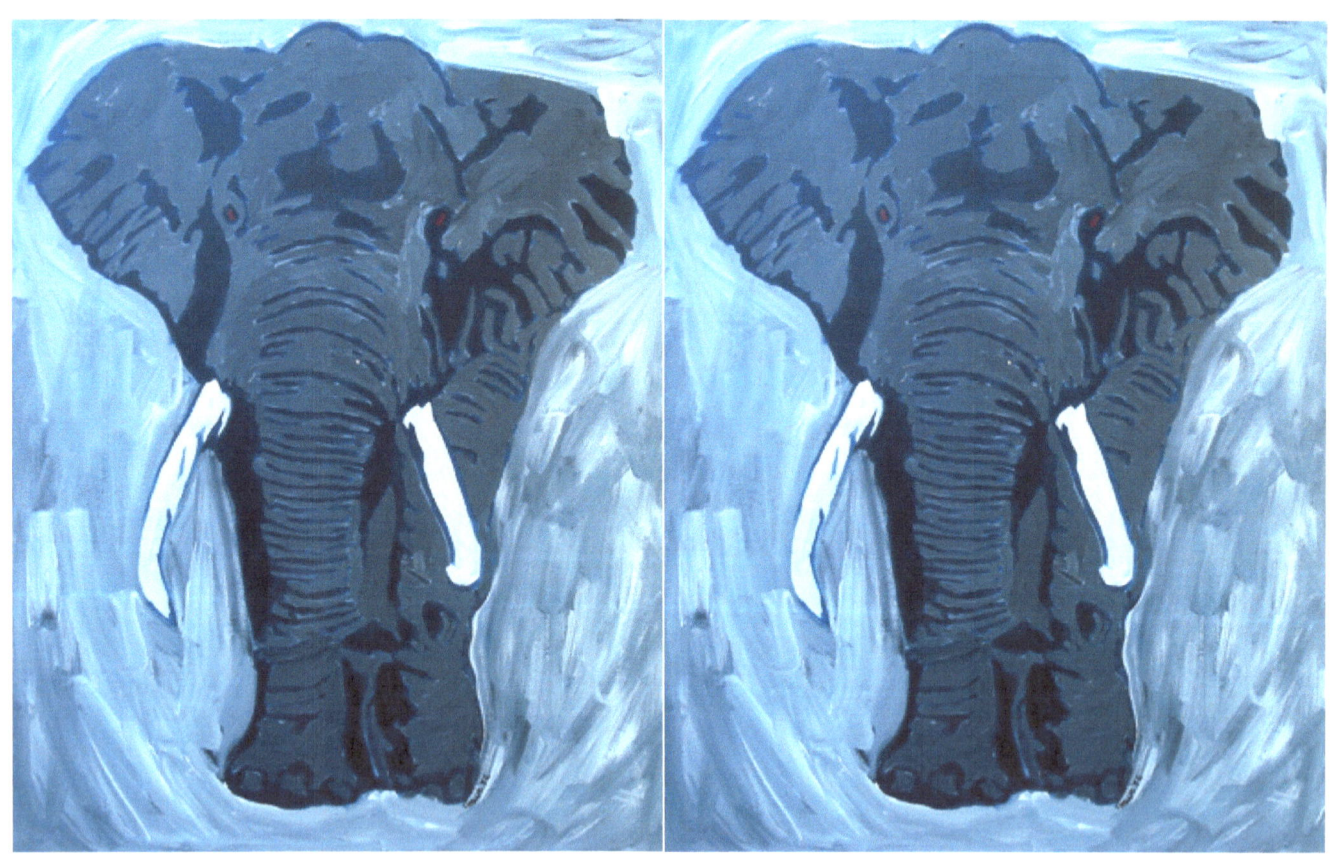

www.ingramcontent.com/pod-product-compliance
Lightning Source LLC
Chambersburg PA
CBHW051049180526
45172CB00002B/564